INTERIOR

AMERICA

Wintersville, Ohio, 1971

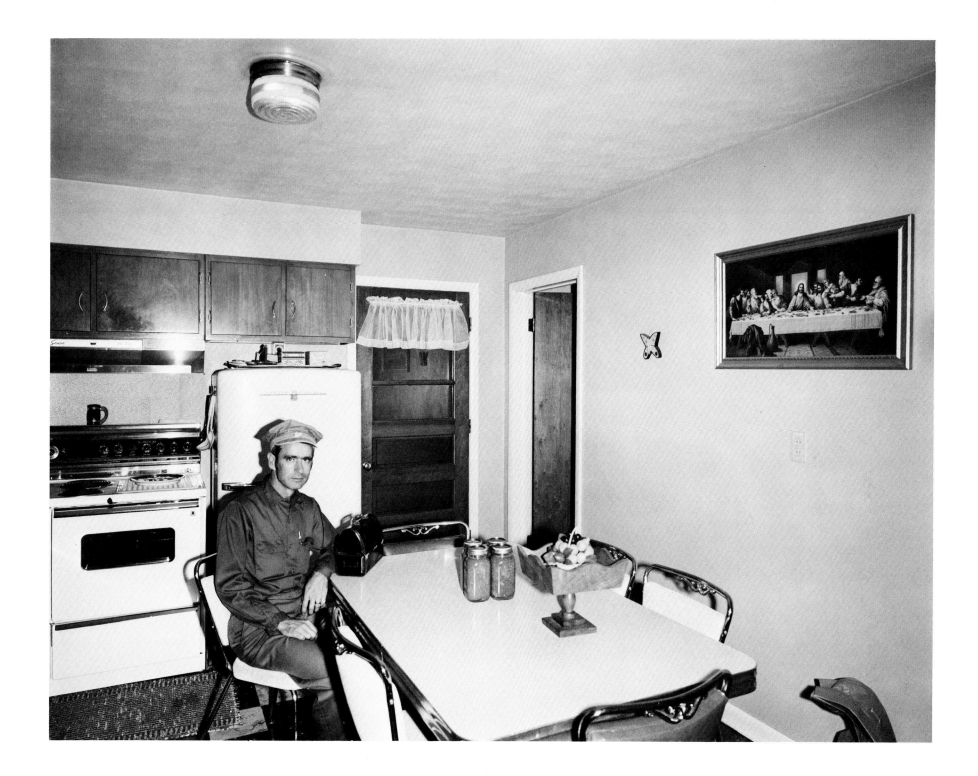

INTERIOR AMERICA

CHAUNCEY
HARE

Designed by Marvin Israel and Kate Morgan

An Aperture Book

Aperture, Inc. publishes a quarterly of photography, portfolios and books to communicate with serious photographers and creative people everywhere. A complete catalogue will be mailed upon request. Address: Millerton, New York 12546.

All rights reserved under International and Pan-American Copyright Conventions. Published in the United States by Aperture, Inc. Copyright © 1978 Aperture, Inc. Library of Congress Catalogue Card No.: 78-66663 ISBN: 0-89381-028-2 Composition by David E. Seham Associates, Metuchen, New Jersey; printed by Halliday Lithograph Corporation, Hanover, Massachusetts; bound by Sendor Bindery, New York City. Manufactured in the United States of America.

Interior America is supported by grants from the National Endowment for the Arts, Washington, D.C., a federal agency, and The Florence V. Burden Foundation.

FOR THOSE WHO ARE AWAKENING TO THEIR OWN AUTHORITY

What is a rebel? A man who says no: but whose refusal does not imply a renunciation. He is also a man who says yes as soon as he begins to think for himself.

Despite the fact that this runs counter to the prejudices of the times, the greatest style in art is the expression of the most passionate rebellion.—Albert Camus, *The Rebel*

To be white, male, twenty-two years old, with a new wife and an engineering degree from a prestigious university, was just about the best thing that a person could be in 1956. The Russian launching of Sputnik was only a year away, and it would send America rushing pell-mell into many technological races: aerospace, computers, plastics, to name a few. Concerned about the space "gap," President Eisenhower elevated engineering from a well-paying profession to an act of patriotism. In that graduating spring more than twenty years ago, I possessed all the credentials of the American dream as we then knew how to dream it. With a chemical engineering diploma from Columbia University, and my bride, Gertrude, from Niagara Falls, New York, I set off for California. In Richmond, a new job waited in a Standard Oil of California research lab. To all appearances, I was a young man who marched to the right drummer.

But something was wrong, right from the start. For one thing, there was height. I have since discovered that most good photographers are about 5'7"; all successful corporation men appear to be around 6'. I am 5'6". More significantly, there was something wrong inside. A good personnel recruiter should have spotted trouble in a young engineer who had spent extra energies getting both a bachelor of arts and a bachelor of science degree. Much of my free time at Columbia had been devoted to reading literature, visiting galleries and attending opera performances. I took short-story writing courses at night. And my

grades were higher in the arts courses than in the engineering studies. Actually, my dissatisfaction with the corporate engineering mold went back to childhood.

My grandfather and father were both men in tune with their times. Born into a family of blacksmiths, the elder Hare was of the generation that made the transition to steelworking in the mills of Pennsylvania's Monongahela Valley just after the turn of the century. Even full-time work in the mills provided only a meager existence in the surrounding villages. My grandfather lost the use of a leg in the mill. And my uncle was partly maimed in one leg by tuberculosis, which was common in those impoverished communities of pre-union laborers. I feel that my camera recalls such experiences when it trains upon modern industrial casualties. The slumped figure asleep on a porch swing in Mingo Junction, Ohio, is one-armed (page 51), and in the background there lies the grim panorama of the mill. It was pure *déjà vu* for me—the mill, the porch, the lost limb. It brought back my grandfather.

My father was born into a home that was little more than a chicken coop. If his father was of the generation of victimized labor, my father, Ross, belonged to a period of American history when opportunities greatly expanded for men of strong will. He entered Penn State with a small scholarship and paid his way through with odd jobs and loans from relatives, whom he repaid by working as a draftsman during the summer. The jobs in college included stoking a fraternity house boiler. It is tempting to imagine my father plying his dirty work in the basement, vowing to be richer one day than the fraternity boys sporting in the rooms above. After graduating with a degree in mechanical engineering, Ross went to work in a plant in Niagara Falls, where he married a young stenographer.

I was born in Niagara Falls in June 1934. As a child, I was undersized, poor in sports, but always at the top of my class—attributes that can guarantee a lonely American boyhood. We did not have a rich family life. My mother was beautiful and intelligent, but she kept it all under wraps. She made herself insignificant. She would suffer long depressions and lock herself in her room for days. In

1942 a brother was born, but I have never had any feelings of close contact with him. When I was fourteen, my parents bought a dentist's brownstone house and the suite of offices was turned over to me. That helped perfect my isolation at home: after school each day, I went to my rooms and read, well away from the rest of the family. Meanwhile, my father successfully battled his way upward. In the mid-1950's, he wound up as manager of a DuPont electrochemical installation in Niagara Falls—an enterprise with a labor force of about 1,500.

From 1943 to 1945 the family experienced mysterious transfers. With no explanation, we moved first to Wilmington, Delaware, then on to Richland, Washington. When news was broadcast of the nuclear bombing of Hiroshima, my father announced, "That's what I've been working on."

As I look back on it, I know I never liked the life my father led. He was influenced by the need for recognition, including various status symbols. He had a special place to park his car at the plant, and a particular employe who washed it for him. This was important to my father. Ironically, just as I was finishing up at Columbia, his world turned on him. I had just started working for Standard when Ross suddenly retired from DuPont—for reasons that are not clear to me even now. He taught for a while and tried consulting, but it seemed that my dad just could not function without the corporate setup—the clear-cut organizational structure and all the subordinates. In perhaps the most personal photograph in this book, my father is seen napping in a chair (page 173) during Christmas time of 1971. He was ill then, suffering from an undiagnosed cancer. After recovering successfully from an operation, my father now continues his Bible studies, and he is also taping recollections of his life.

It seems strange to others that I went into engineering, even though the life did not appeal to me as a child or in college. The fact is that it just never occurred to me—growing up in that environment—that I would not be an engineer. Nothing else was ever suggested. I just assumed all along that that was what I would be. And I approached

marriage in much the same way. I was home from school on vacation in 1953 when I met someone as shy as I was. Her name was Gertrude Lang, and she was a recent immigrée from Austria. Only fifteen years old, Gertrude was working as a waitress, and I think we were both surprised when I worked up the courage to ask for a date—and she accepted. At school my romantic life was nonexistent. I could sum up my whole social life at Columbia by saying that I lived on the sixth floor of John Jay Hall at first, and then I moved to the eleventh floor. I had maybe two dates in New York the whole time.

Gertrude knew very little English when we met; I had only a smattering of German, which was an engineering requirement. It made little difference, because we did not talk very much. Nor was it a passionate courtship. We were shy and lonely, and we found some comfort in being together. I never exactly planned to marry Gertrude. I never planned to marry. It just never occurred to me that I wouldn't, and after I met her it never occurred to me that I wouldn't marry Gertrude.

Despite any hidden or unexpressed doubts, my childhood and youth were a smooth progression toward the Standard Oil refinery in Richmond, California, where I would work for the next twenty years. The job itself held no happy, unexpected surprises. I was discontented from the first day.

A refinery is a nonstop jigsaw puzzle of tanks, vessels, pipes, valves, meters and gauges—all dominated by imposing distillation columns. Crude oil or crude oil fractions are pumped into these columns, where through intricate manipulations of pressure and temperature, further oil fractionation takes place. The products, freed of their residues, are blended with additives to make any of 200 different kinds of fuels and lubricants that feed and grease America's machinery. There are literally thousands of things that can go wrong.

Your life and mind are filled up by what goes on in those idiotic columns! Arriving at eight o'clock each morning, my job was to check printouts and reports about the columns' performance the night before, and to find quick

solutions if something was amiss. If the petrochemical products did not meet exact standards, they had to be pumped back into the towers and refined again. Such recycling is costly—it lowers corporate profits and spirits and even, you begin to feel, incurs the alchemical displeasure of the column itself. My work also included long-range preparations for products scheduled for refining months hence. Even though I was offended that people should have to live with readings and numbers in their heads all day, I have to admit I did not mind the technical work as such. In fact, if engineering could be accomplished in a human way, I'd probably still be an engineer.

The rub was the human side of the refinery—if it could be called that. Smooth operation of the plant required team action; successful performance, according to the corporate authoritarian ethos, demanded untrammeled competition. Resolution of these two conflicting demands is achieved by eliminating any sense of personal human contact. For example, I shared an office with another engineer and we should have been friends—in more than the usual artificial way. He was an interesting guy, who used to go mushroom hunting after rainfalls. But there was no way we could, as engineers in that environment, break through the wall of competition to relate genuinely on a human level. Another colleague, named Monty, was one of the best engineers I ever met and a thoroughly human one at that. He could not project a dynamic image at meetings, though, so they fired him. I was not a big enough person at that time to protest the firing. It was not the only failure to speak out that I regret.

Early on, I was assigned to a project to study ways of eliminating nitrogen dioxide—the highly visible, eye-stinging effluent that emerged from one of the stacks in the refinery. Two solutions were possible. The first was to raise the temperature to a point where this contributor to smog and emphysema would be rendered colorless, though still active and harmful. The second was to employ catalysts—at an additional bienniel cost of $30,000—to transform the effluent into harmless nitrogen. Because there was no government regulation controlling pollution at the time, the

team I worked on recommended the camouflage. I was then twenty-four—a kid, I had no human values.

I was given to unreasoning fears about losing my job. But I never worked vigorously toward promotion. This would have entailed rating other engineers, determining their career progress, and so would have contributed to the competitive attitude that I intuitively opposed. To safeguard my livelihood, I dedicated myself to mastering the technical aspects of the job, and so hoped to make myself indispensable.

My first refuge from the misery of my work was fishing. I went into the mountains on weekends, and I was one hell of a driven fisherman. If a trout ever got off the hook, it killed me. I'd go after it with a net. In 1958, still looking for some kind of escape, I bought a 35mm camera and set up a darkroom in a cramped apartment closet. I still have that camera.

From the moment I started taking pictures, engineering became just a way of making a living. Everything went into the photography. I was too shy to approach people, so

I was naturally drawn to landscapes and went camping each weekend to photograph California's mountains. I went for light and dark shadows, light playing on mountainsides, dramatic content. Ansel Adams stuff! My background in chemistry and an admitted compulsion for details helped me make progress. That first year, however, I was too self-conscious to show my work to anyone. The negatives were developed and printed in the closet darkroom and then stowed in a box.

In 1962 I bought my first view camera, a Burke & James 5 x 7—a large, unwieldy instrument on a tripod. It was an indicator of a commitment to some type of exploration. There was the greater tonal range and the integrity of detail that made an excellent print. In some fashion, acquisition of the view camera was symptomatic of the growing split between my life as a discontented engineer and as an emerging photographer. This schism led to an unpleasant physical manifestation. That year I began vomiting in the mornings. One out-of-town attack frightened bystanders so badly, they rushed me to a hospital emergency

room. Doctors diagnosed ulcers—one suggested removal of the gall bladder—but none could find clear evidence of what was wrong with me. I would have nothing to do with the surgical remedies, so I lived with the condition for the next five years. And it had a schedule. On Monday morning, just before leaving for work, I would have a nausea attack. The nausea and vomiting would persist through Wednesday, then begin to ease up, disappearing on Fridays when I took off for the mountains with my photographic gear. On weekends my stomach was at peace.

It was about this time that I began showing some photographs. The landscapes won a favorable response. In 1964 I had a show at the San Francisco Museum of Modern Art, and a year later at the city's M. F. deYoung Memorial Museum. These advances as a photographer not only helped take my mind off work, but also began to pry me away from my marriage.

I have always cared deeply for Gertrude, and I respect her. She is an intelligent, hard-working woman, who had no particular ambitions of her own that she was able to express to me. There was, I believe, a similarity between my marriage and my father's relationship to my mother—in which the woman was a shadowy, almost insignificant partner. Through photography, I had embarked on an exploration of myself, but it was not something I was able to share with Gertrude. We seldom spoke to one another. Even our most intimate moments were less than satisfactory compromises between her instinctive opposition to birth control and my reluctance to have a child.

At my insistence, Gertrude attended the University of California at Berkeley, ultimately earning a master's degree in library science, and started working successfully upon a career of her own. I spent little of my free time at home. If there, I was locked away in the darkroom. It was in 1965 that I finally became aware of my total commitment to photography—and I'll never forget it. We were driving down the hills of Berkeley in our 1962 Rambler American. I told Gertrude that I had to do something with my life, that I felt I had some kind of undefined destiny. Later that year our son, Victor, was born. He must have sensed that he

wasn't wanted at first: he didn't talk for the first six years.

The mid-sixties may well have been the lowest point in my life. I was miserable at work. My stomach was so sensitive I could not stand even the tension of a spy movie on television without rushing to the bathroom. I was a husband and father in name, but found no satisfaction in either. Even the photography was stagnating.

I was deeply moved by the humanity of the documentary work of Walker Evans and, even more so, of Russell Lee. But the long years of self-imposed isolation were too deeply ingrained for me to attempt aiming a camera at another human being. Still, there was interest in the work that I was doing. In 1967, after looking over some photographs, Minor White wrote to me: "You are on the verge of a breakthrough." Ever the mystical guru of American photography, White was again prescient. But I needed help to break down the walls I had built around myself, and the help that came was unexpected, simple and effective.

On a lunch break in March 1968 I was wandering around a picturesque residential area, a hodgepodge of 1930's architectural tastes, near the refinery. As usual, a 2¼ x 3¼ camera was slung over one shoulder. A heavy-set, plain-spoken man in his late fifties walked up and offered to sell a camera. His name was Orville England, and after chatting a few moments he invited me home, where I met his wife, Helen. Relaxed by the easygoing manner of the couple and the simplicity of the surroundings, I asked if I could take some photographs the next day with the view camera. Orville and Helen did not mind, and the picture of Orville by the stove became the first look into Interior America (page 165).

Orville and I became good friends. Being around the matter-of-fact former refinery employe relaxed this tense, admittedly repressed engineer. Through some peculiar human chemistry, acceptance by Orville gave me an increased measure of self-respect and self-trust—qualities suppressed in the aggressive, authoritarian company of my engineering peers. For his part, Orville had been far removed from the engineering elite at the refinery; he had been at the very bottom of the status heap: a stage rigger's

helper. Stage riggers build scaffolding when maintenance or repairs are needed on large pieces of equipment. Orville, a man with few problem-solving skills, was an assistant to the man who built the scaffolds. Called over one day to help repair a pipe at the Ammonia Plant, Orville was assured that the pipe was clear. By error, it was still under pressure. When Orville moved it, the ammonia burst into his face and singed his lungs. Through various mix-ups in reporting—some of them possibly deliberate—Orville was eased into retirement with a small pension, no disability, and with the bulk of his own medical bills to pay. As of this writing, I still have hopes Standard Oil will review Orville's case and help alleviate the financial hardships stemming from the refinery accident.

The encounter with Orville and those first pictures inside a stranger's home unbarred the door and gave me the confidence to gain access to other households. Almost immediately, I began eight months of furious part-time effort—about twenty-five pictures. The results of those nights and weekends of work led to a Guggenheim application, and the award came that same year. Elsewhere I have written, and it still holds true: "That Guggenheim in California was the end of thirty-five years of unconscious death. I had one year of life."

I applied for a year's leave of absence for the 1969–1970 grant period and received it, though one supervisor was dismayed that anyone would want to leave the refinery for a year to take pictures. The Guggenheim did me a world of good in terms of photographic work and how I related to people. But it sure didn't help my attitude toward the organization. One wonderful side-effect of the chance encounter with Orville and the Guggenheim: I stopped vomiting and have not since experienced a bout of bad health.

A Guggenheim was also forthcoming the following year, and it helped finance a year-long study in the Ohio River Valley—my father's home ground. It was never easy to gain access and cross thresholds, but I felt the awakening of a new determination. I worked in a stubborn, ironical, rebellious, yet empathic frame of mind. I could not proceed without the stubborn intention of entering and photograph-

ing homes. I feel that this rebellious frame of mind—in the existential sense, a striving for unity—is even now the primary source of psychic energy for my work.

I soon developed techniques to make the transition from outsider to insider. I solicited letters from museums, libraries, the Guggenheim Foundation and several state governors. These I assembled into a portfolio that presented the bearer as a serious photographer. Knocking on doors that attracted me, I waved the letters and told the astonished resident that I was working on a book of photographs. I wangled my way inside fairly regularly. I also adopted the custom in small towns of first stopping by the local police station and introducing myself. This helped when cautious souls called the station to inquire after the identity of a person they were convinced was a high-powered salesman, or worse.

The techniques of entering a home and framing a picture are products of experience. More important, however, is magic. A quality of magic came into existence early in the first Guggenheim. Things began to happen in an uncanny

way . . . people expecting me when I had not met them before. Magic is for many people a troublesome word. I think that it was best described by the French sociologist Jacques Ellul, who wrote in *The Technological Society*, "The world in which man lives is for him not only a material but also a spiritual world; that forces act in it which are unknown and perhaps unknowable; that there are phenomena in it which man interprets as magical. . . . This whole area is mysterious."

To cite an example, I was in a mission flophouse in Chester, Pennsylvania. I had found the photograph, the camera and light were primed—yet I just couldn't take the picture. Suddenly, a man walked out of a door I didn't even know was there and came toward me. I shot off the strobe light. He glared at me and said, "You sonofabitch," and walked on by. That was the picture I was there for. That, to me, is magic. (page 39)

Once inside a home I find the photograph very quickly, because there is only one picture for me in a place. I hardly ever take more than two. If someone tries to keep

me from looking somewhere, say, an upstairs bedroom, that's where I know I've got to go. That's where the picture is. At first, everyone professes to be too busy to let me in, but normally it turns out that everyone has plenty of time. Also, people always apologize for the condition of their homes, while at the same time being proud of them. I've also discovered that by evening most of masculine Interior America is a little bit drunk. And television sets are almost always turned on. These odd bits of social fact have only a partial significance in the photographs. The pictures carry a more complete message that I am responsible for.

What I am looking for is best found by looking at the photographs. I do not want to mystify their meaning, but what they say is something that I cannot easily put into words. At the same time, the photographs are explicitly literary: each has its own story, and suggests many more to an empathic viewer. I admit to some deception in making a number of these pictures, but under no circumstance would I allow any to be used for commercial purposes. The deception involves the use of a wide-angle lens, which en-compasses more of the room than the homeowner probably suspects. Several subjects in the margins of the pictures very likely did not know that they were being included. This wider perspective is the only way I could get the photographs to carry the message of rage. I'm not exactly proud, though, of what I had to do to get the pictures, which to me show severe alienation in this country.

Homes and public buildings were not the only interiors I sought out. The urge for discovery went within as well, and I began exploring my own inner fortress of defenses and inhibitions. I began a series of studies of women, some of them prostitutes. I came to know several of them as a friend and lover. And for a while, I was immersed in the lives of a heroin-addicted prostitute named Jacquie and her daughter, and also became acquainted both with Jacquie's pimp and with her mother. I tried to help Jacquie break the addiction and solicited help from welfare agencies. These efforts did not succeed as far as she was concerned, but I found that for the first time I was able to reach out compassionately and care about another life.

Despite the many changes taking place in my life, there are those who believe that I am an intolerably slow leave-taker. Gertrude and I had been growing apart for years—a process no doubt hastened by my experiences with the women just described. My values were changing and I was increasingly restless at the mold I felt embedded in. Still, the dissolution of the marriage was gradual. In 1974 I moved down into the basement of the house we had bought, and slept near the darkroom installed there. More than a year later Gertrude and I together worked out a divorce settlement and I moved out. I found a rooming house not far from Orville's home. Later, I met another boarder, an intelligent, searching woman who was questioning her role as a nurse in the institutional environment of the hospital. We managed to give each other comfort and support in our struggles, and also the solitude each sometimes needed.

The departure from Standard Oil was even less clearly defined. After that first Guggenheim, I knew that I could not continue as a refinery engineer. Curiously, the job was far more secure than I had ever known—not because I was a promising engineer, but simply because of the accumulated seniority. I began agitating within the company for changes that would work on the human problems of the corporation and the human needs that were going unsatisfied. In one effort that seems bizarre, even to me, I helped organize employes to defend the corporation against public outcries for breaking up the oil giants. This was after the excessive profits that accrued during the 1973 oil embargo. It was crazy to be defending the company, but I was desperate to find any opportunity that would give employes a chance to determine their own collective destiny. I felt it would inevitably improve the lives and relationships of the people in the company. But it didn't work. No one could see the opportunity for eventual democratization.

I won approval to photograph and tape interviews with Standard Oil personnel, a project completed on a third Guggenheim Fellowship. The goal was to demonstrate the frustrations and emptiness of the lives of corporation

workers. Feeling guilty about these many nonengineering ventures, I volunteered at one point to work for half my $30,000 salary—a request that was denied. Most frustrating of all, efforts to try and get the company to provide compensation to Orville kept encountering dead ends. But I'll keep trying. One picture of my own vision of corporate life captures a young couple seated in an impersonal rented home (page 43), unwilling to venture an individual imprint upon their surroundings. It's spotless, arid, and completely safe—just right in case his supervisor should be invited over. In 1976 I left my regular engineering work at Standard on a leave of absence to continue studying employes. And I never went back.—Chauncey Hare

Postscript: *As of this writing, I have been away from engineering for two years and find that the photography world is not unlike the corporate situation from which I narrowly escaped. Hardheartedness and organizational thinking have stifled creativity and instilled conformity in many photographers. Success, most easily achieved by seeming to "extend tradition," seems to be more important than clear perception and truthful presentation. I am unable to make human contact with many photographers and some photography curators who too often have felt it necessary, because they feared for their own survival, to be closed off and deny their own emotions and true perceptions.*

I see the necessity for restoring moral and ethical values to photography and I am very hopeful that this can be accomplished. I admit to fear—I am worried about survival for myself and others who try to be open. I feel that by joining together with other photographers who feel as I do, possibly on a collective basis, all will be able to survive. The message to fellow photographers is: Realize your own personal power; the character armor displayed by persons in authority is their badge of fear. You have the answer, it is inside you. I wish to encourage you to act on your own true feelings.—C.H.

PHOTOGRAPHS

Steubenville, Ohio, 1971

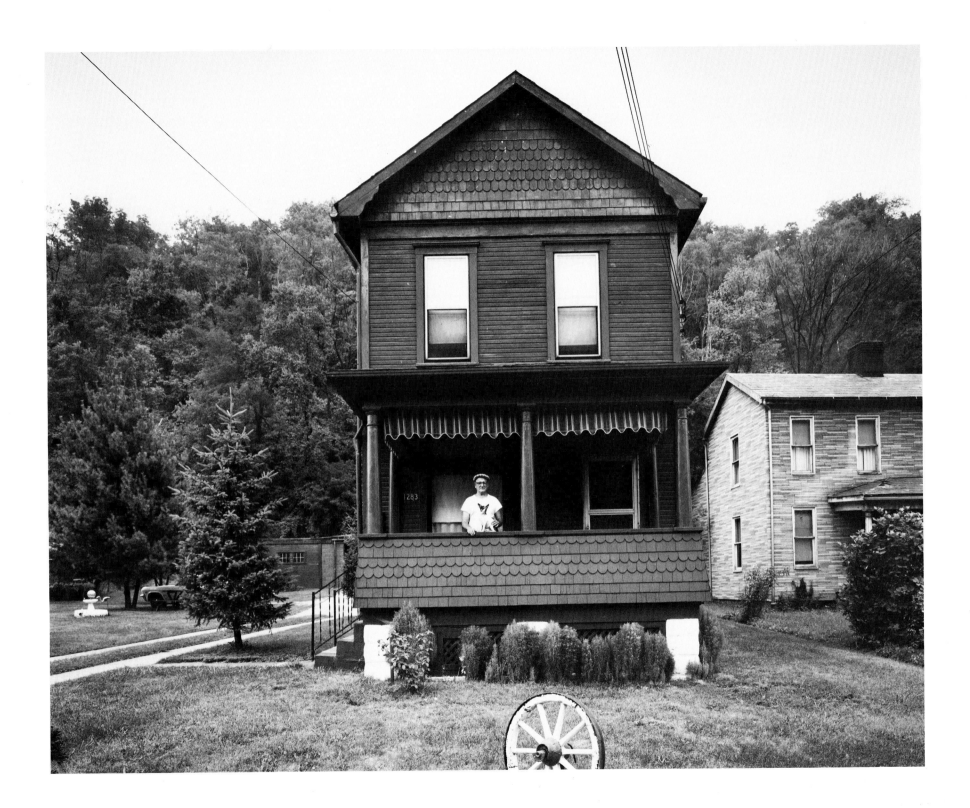

Oakland, California, 1968

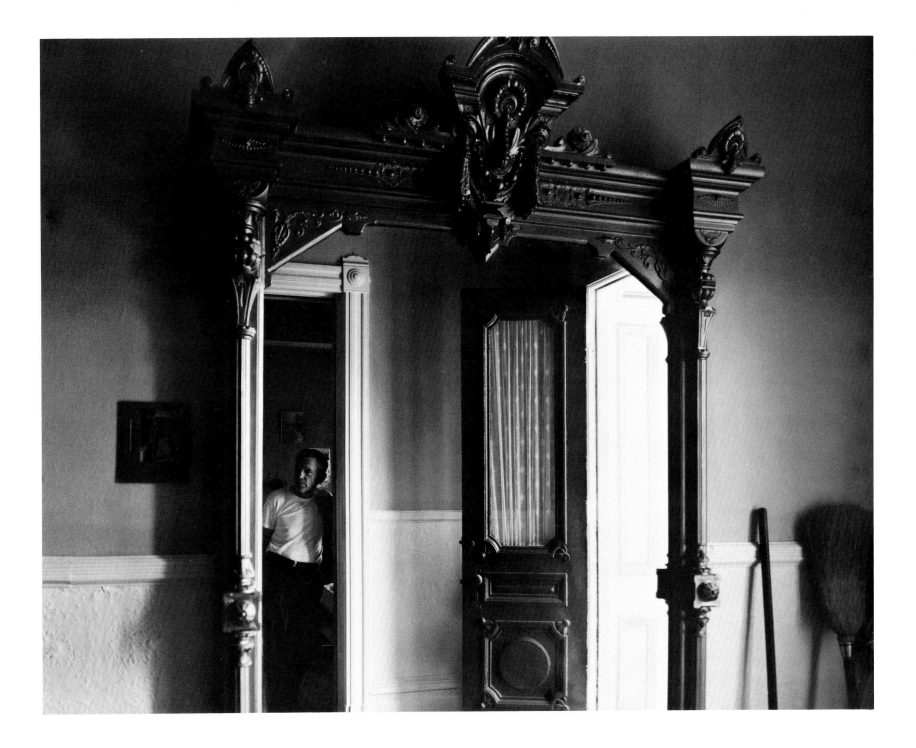

Oakland, California, 1968

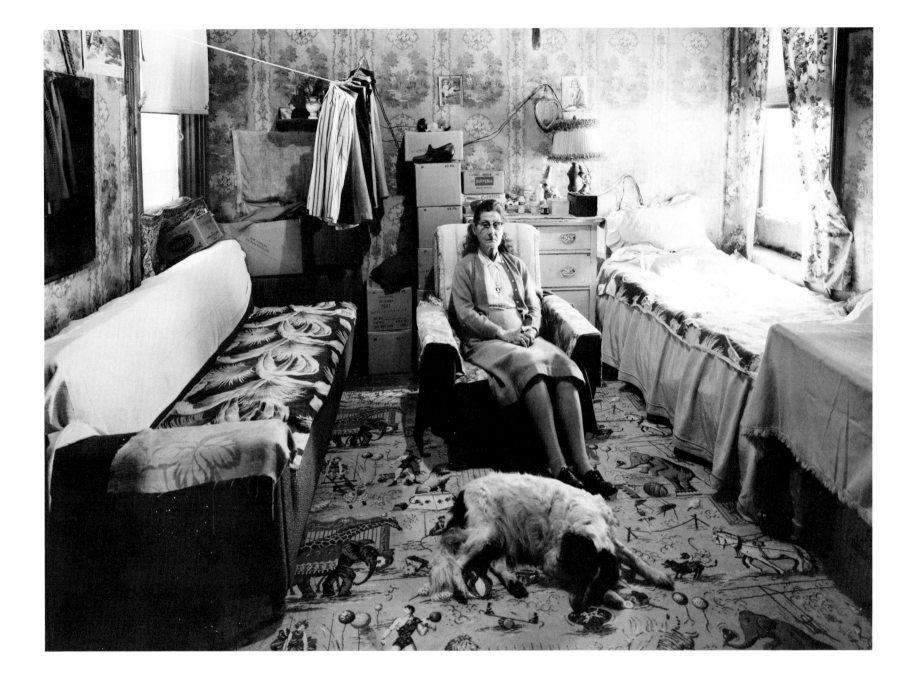

Covington, Kentucky, 1971

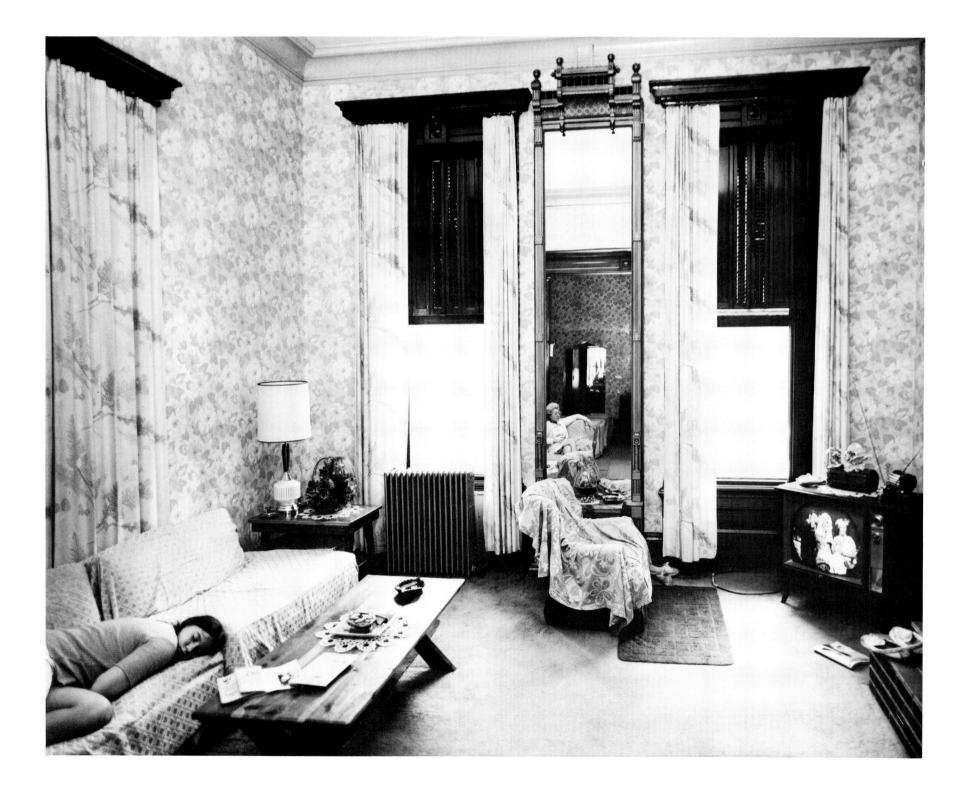

Cheyenne, Wyoming, 1971

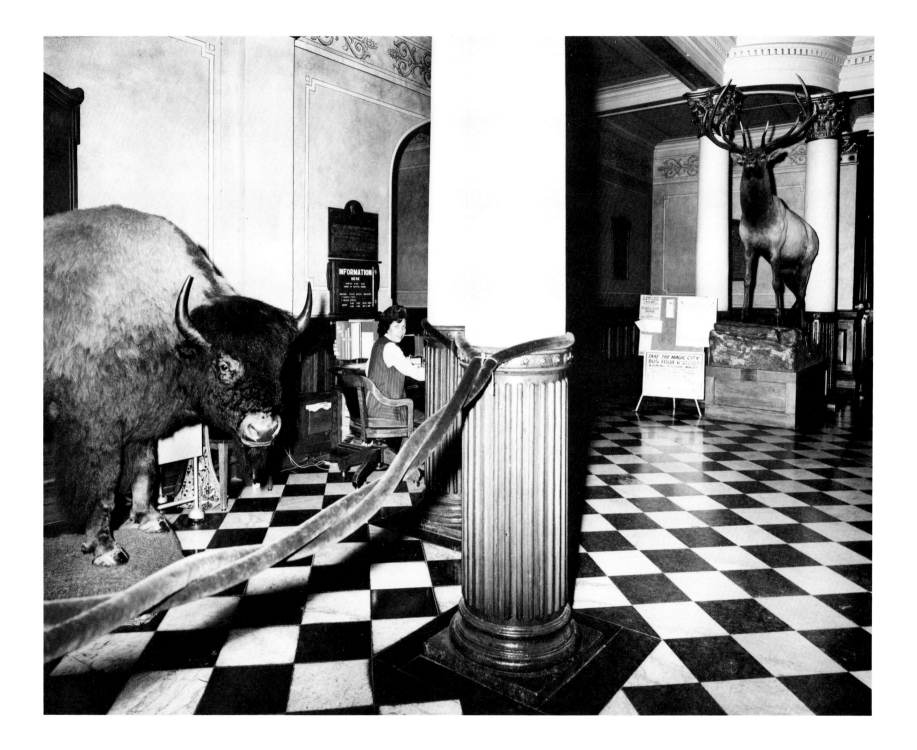

Gilroy, California, 1969

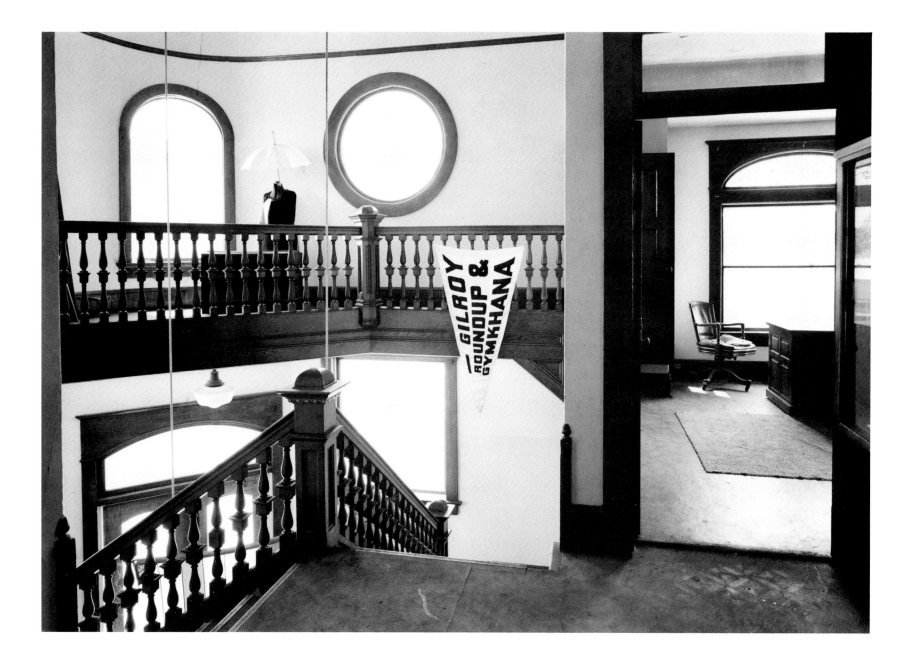

Sacramento, California, 1968

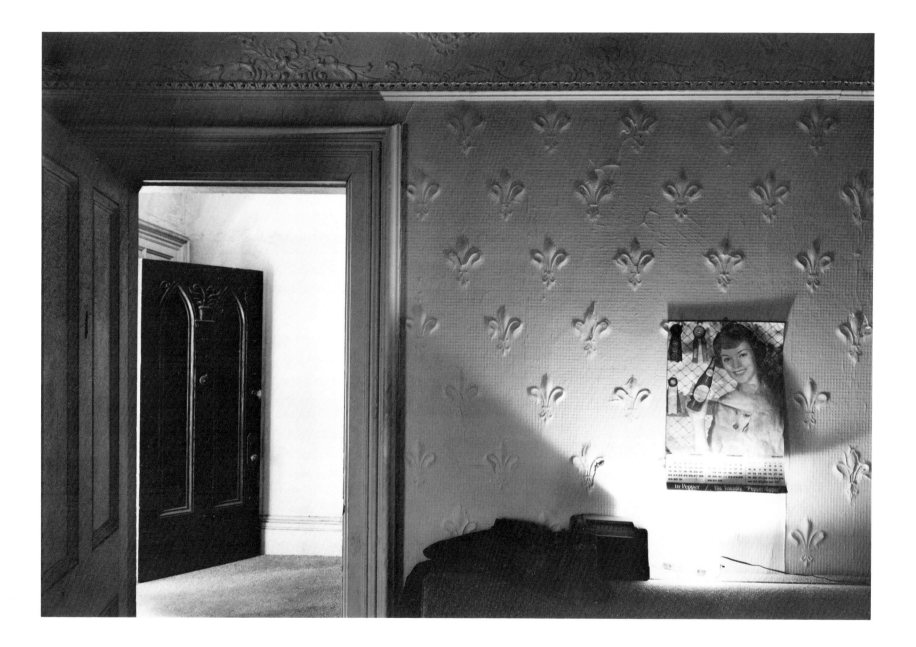

Chester, Pennsylvania, 1972

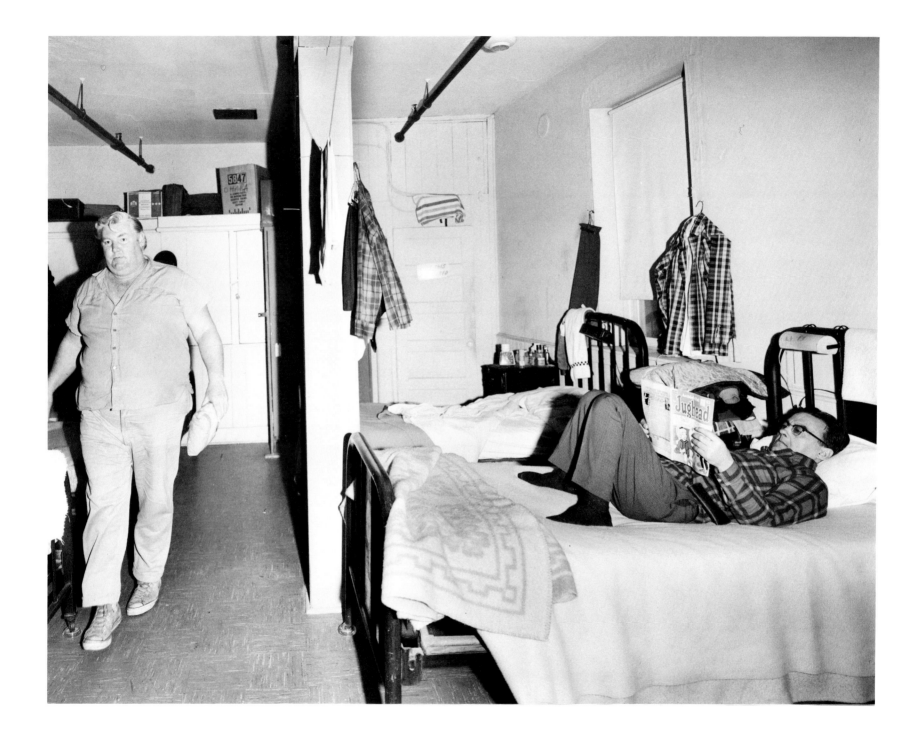

West Chester, Pennsylvania, 1972

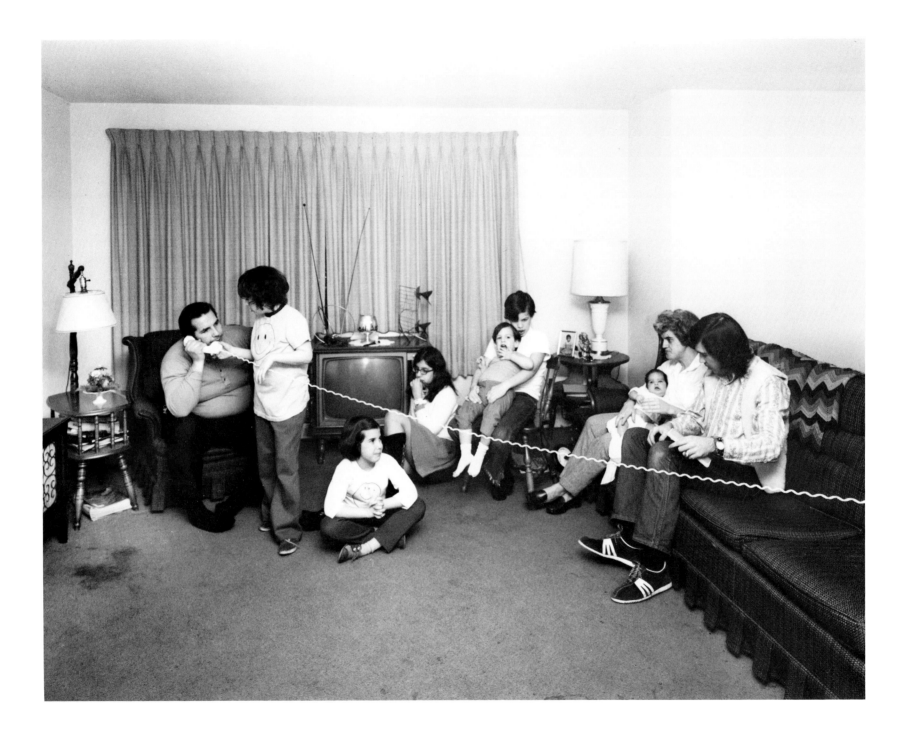

Albany, California, 1968

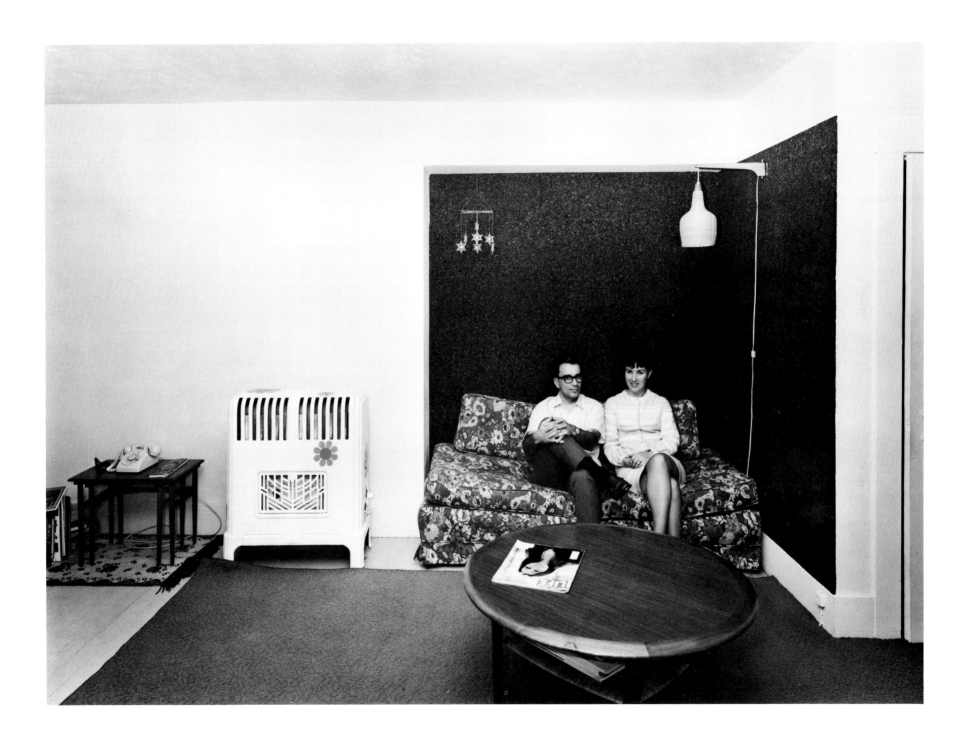

Oakland, California, 1969

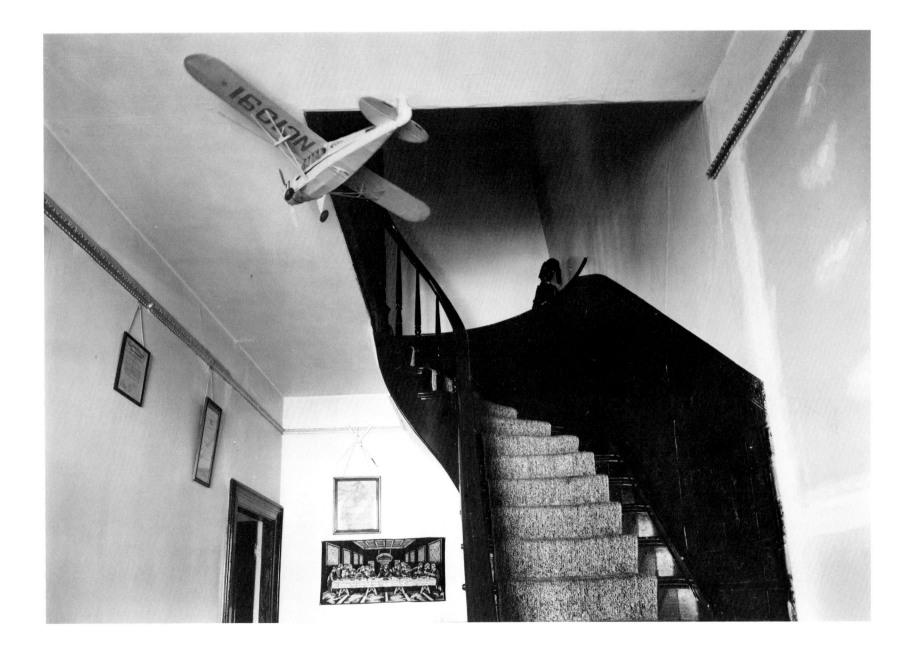

Wheeling, West Virginia, 1972

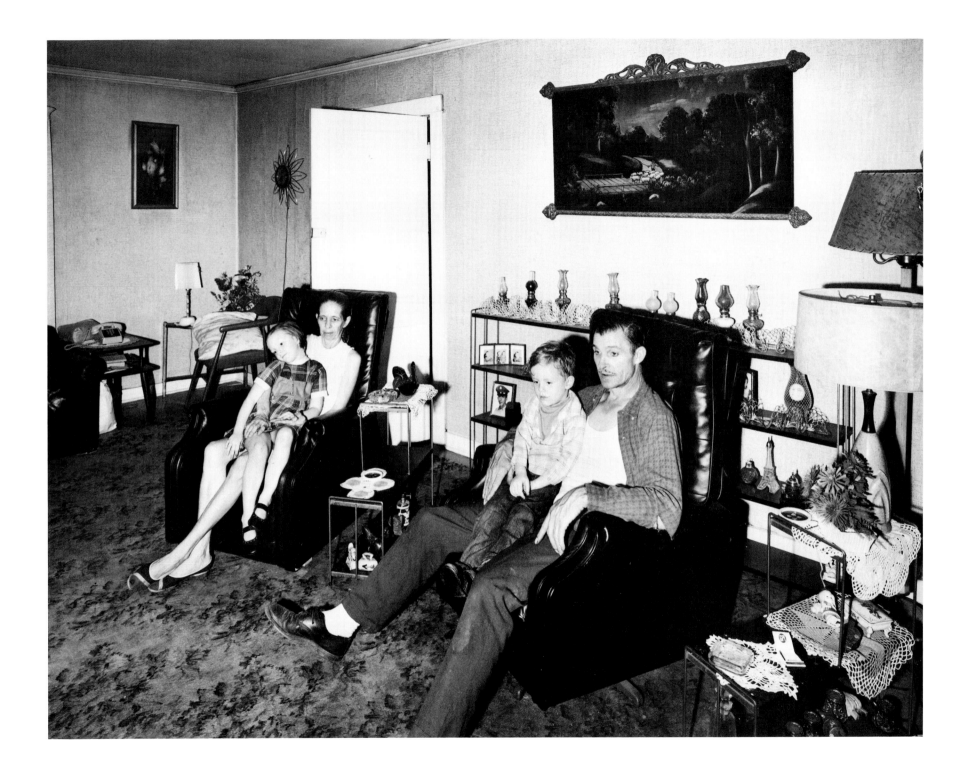

Berkeley, California, 1970

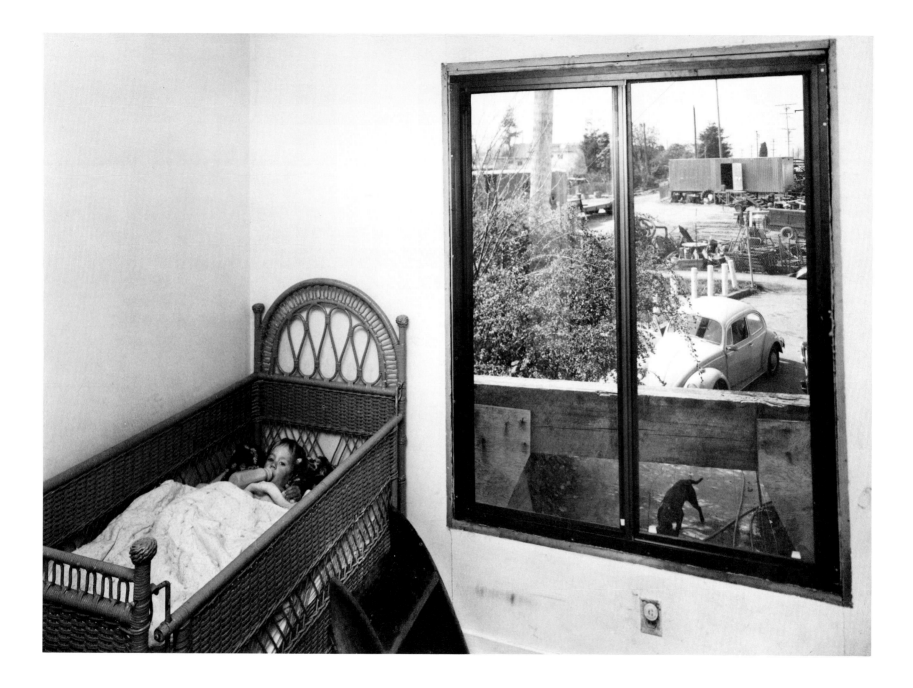

Mingo Junction, Ohio, 1971

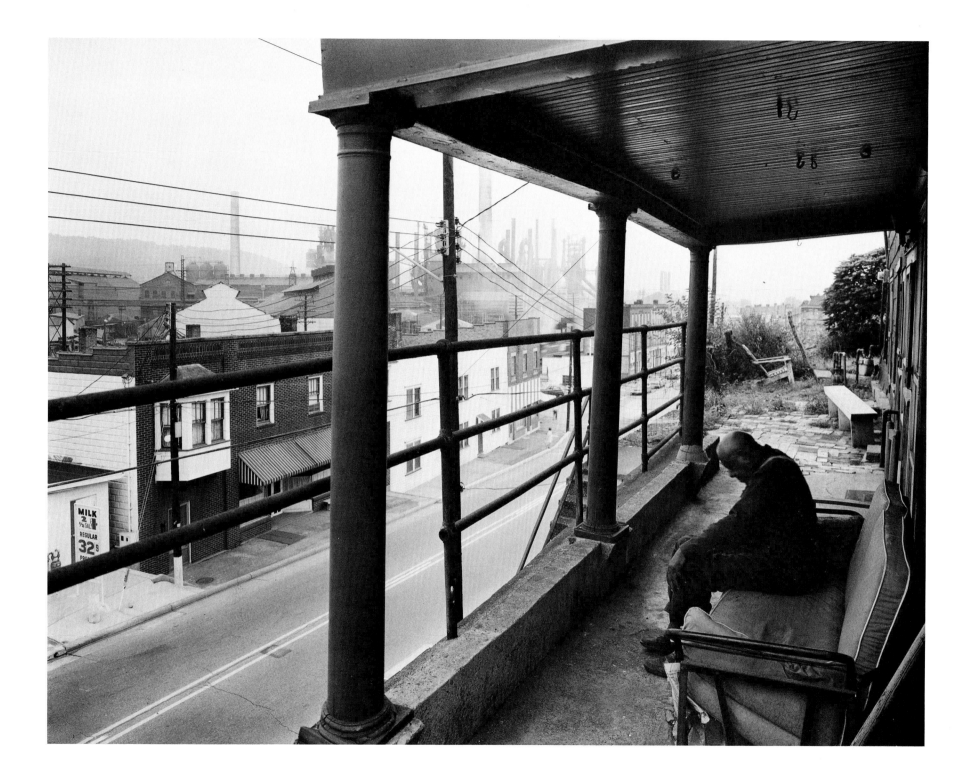

Oakland, California, 1969

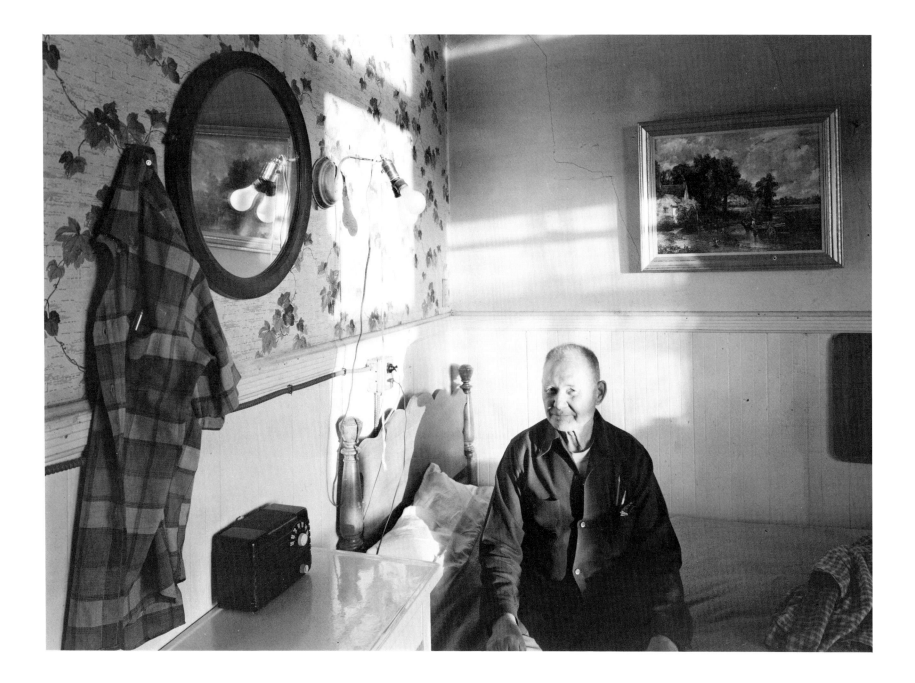

Oakland, California, 1968

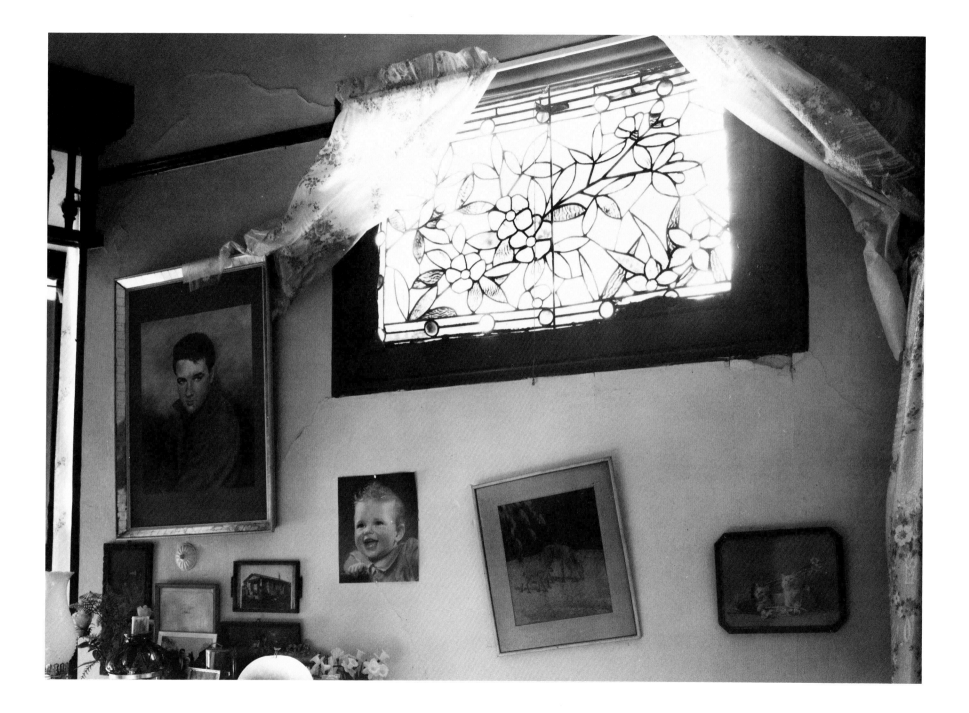

West Chester, Pennsylvania, 1972

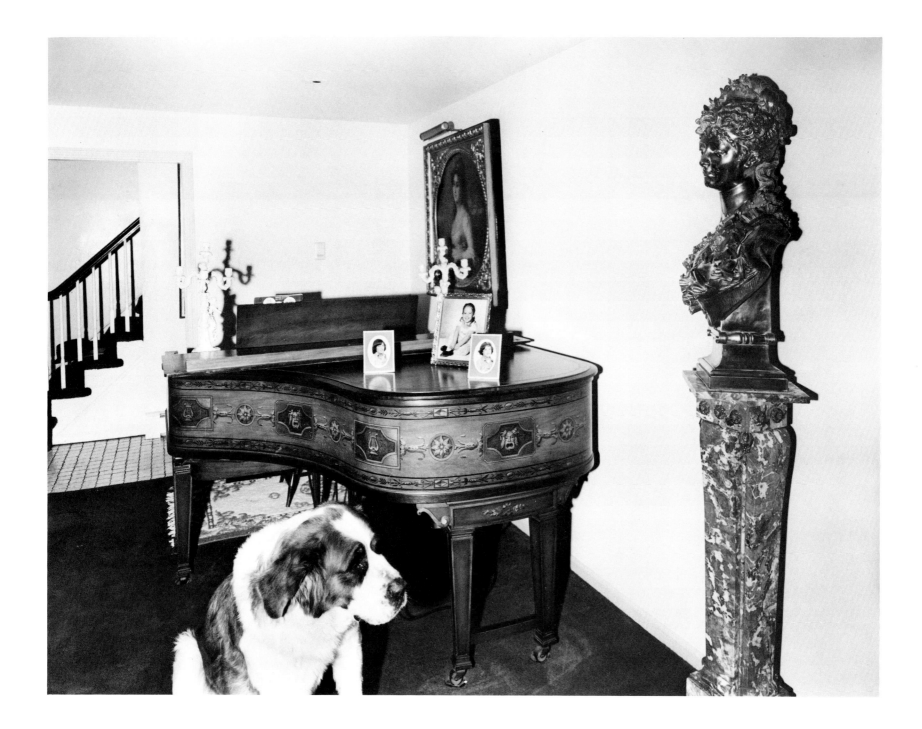

Richmond, California, 1968

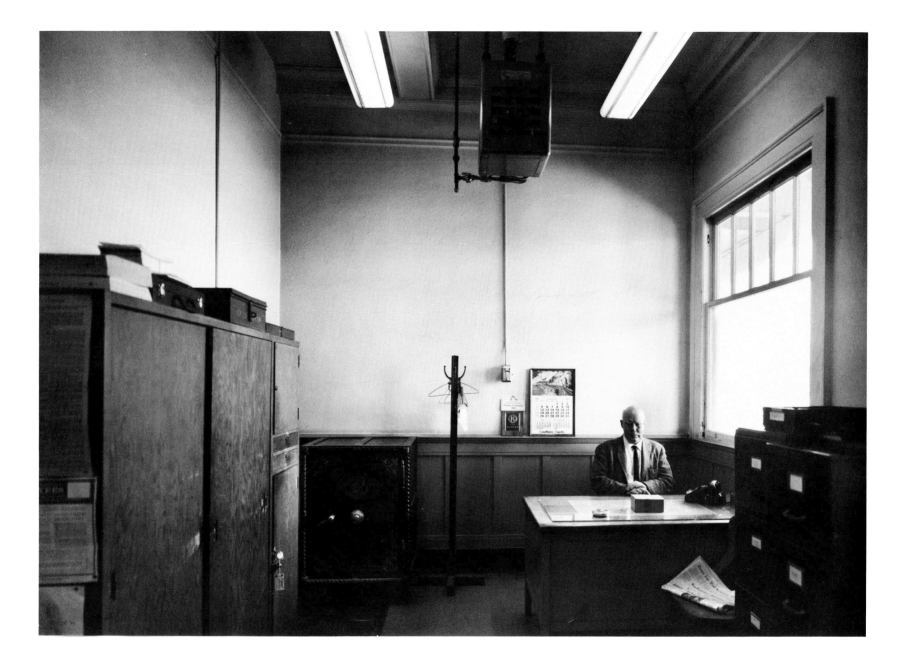

Cheyenne, Wyoming, 1971

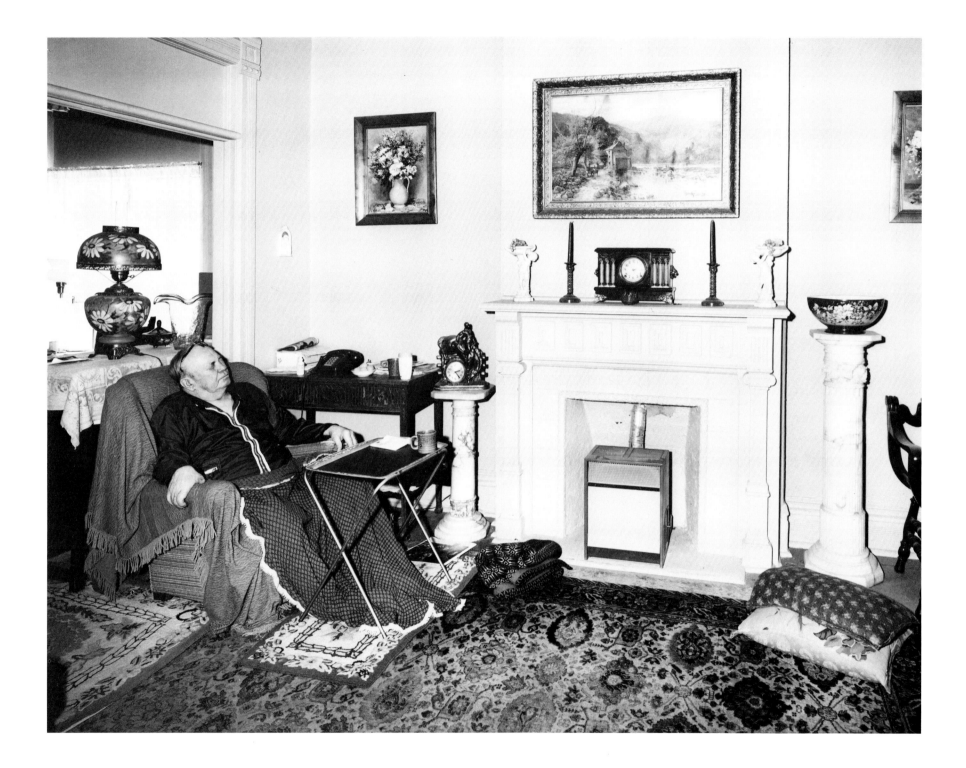

Earlimart, California, 1971

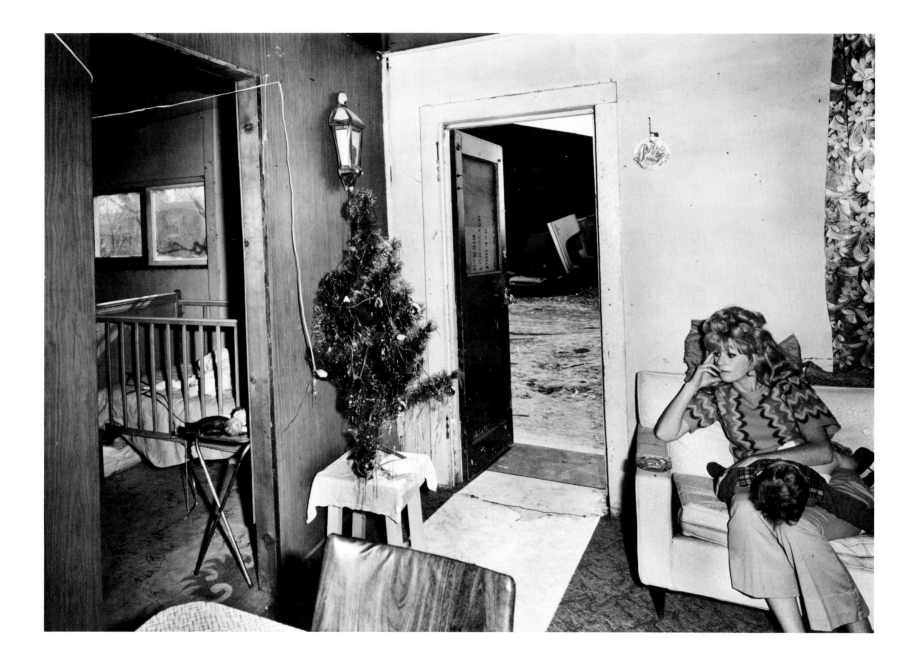

Porterville, California, 1969

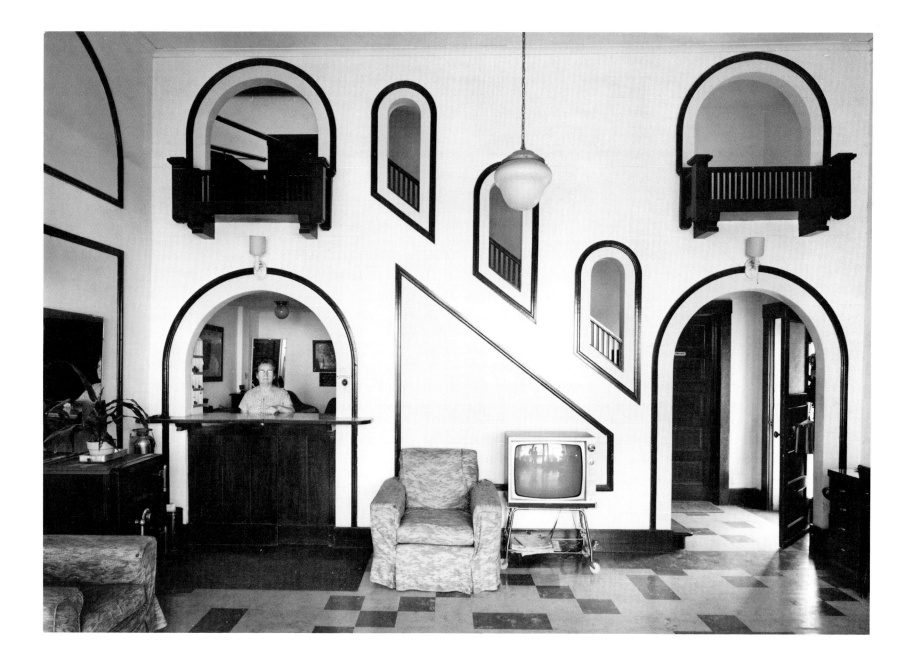

Bethlehem, Pennsylvania, 1972

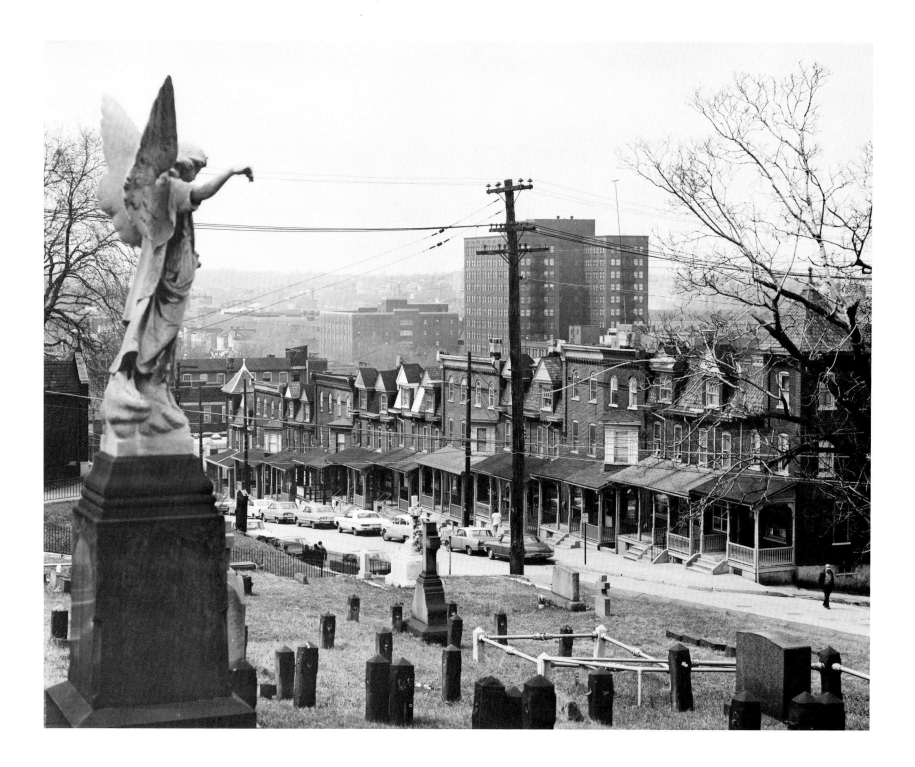

Sierra Foothills, California, 1970

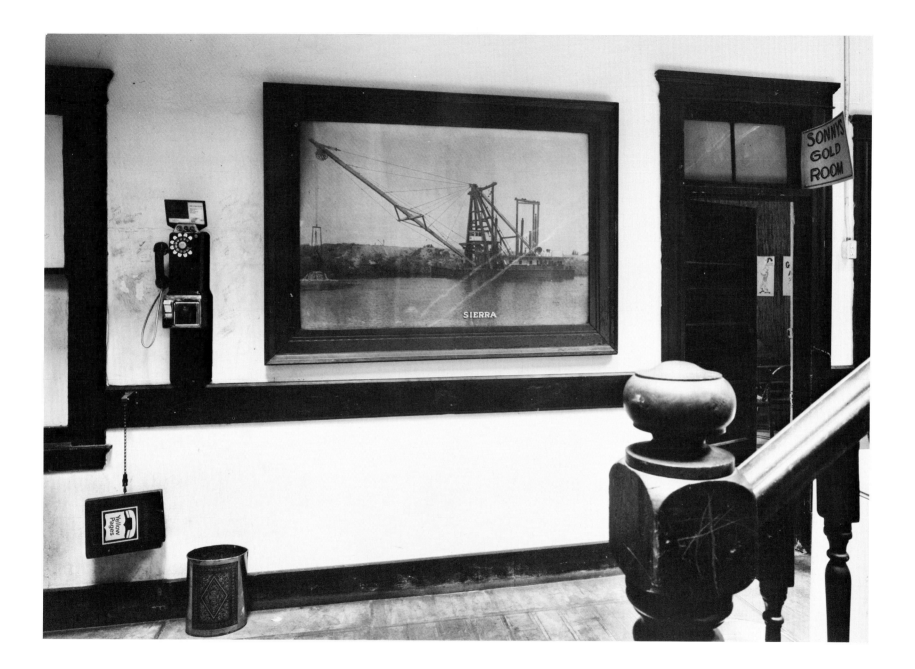

Eel River, California, 1969

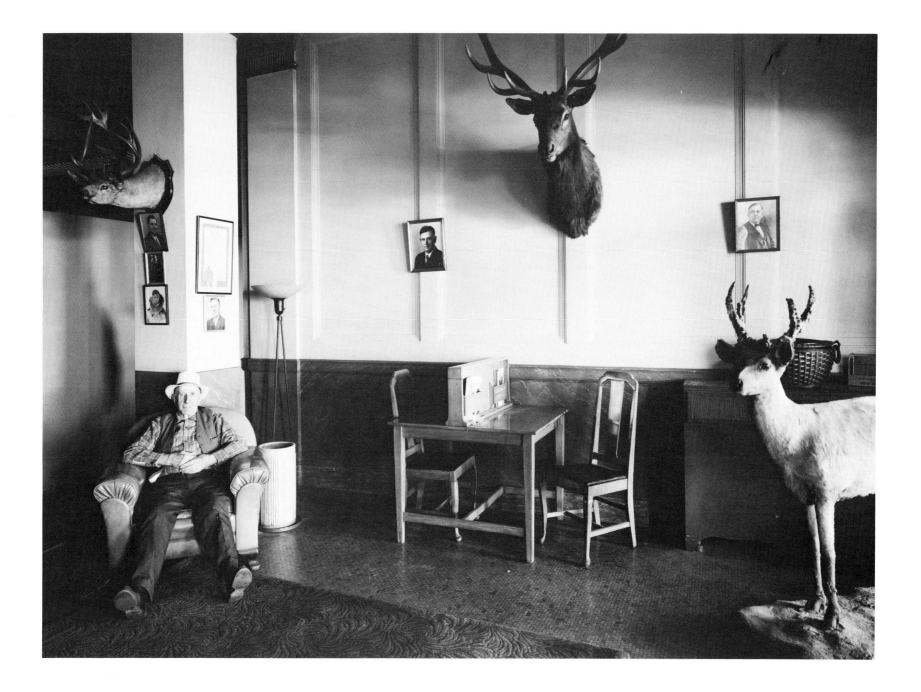

Bakersfield, California, 1969

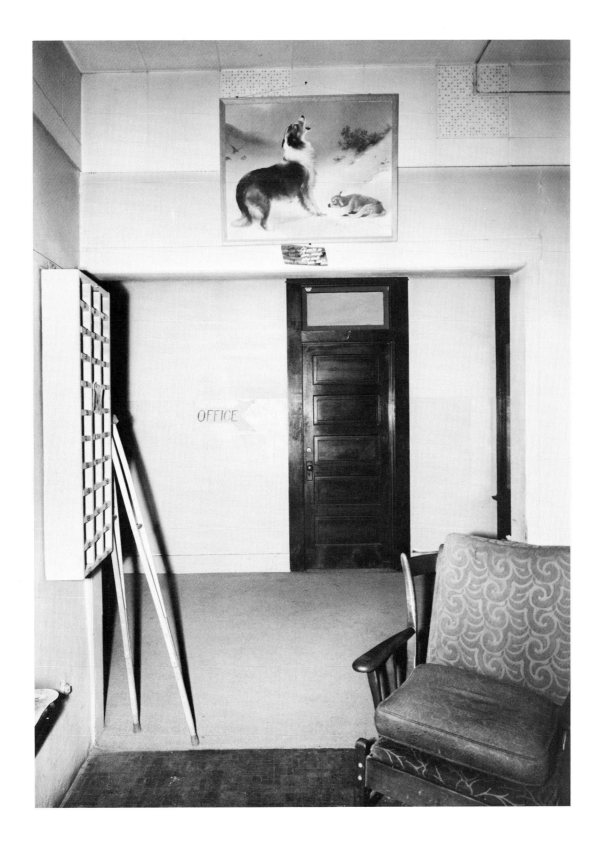

Interstate 80, California, 1969

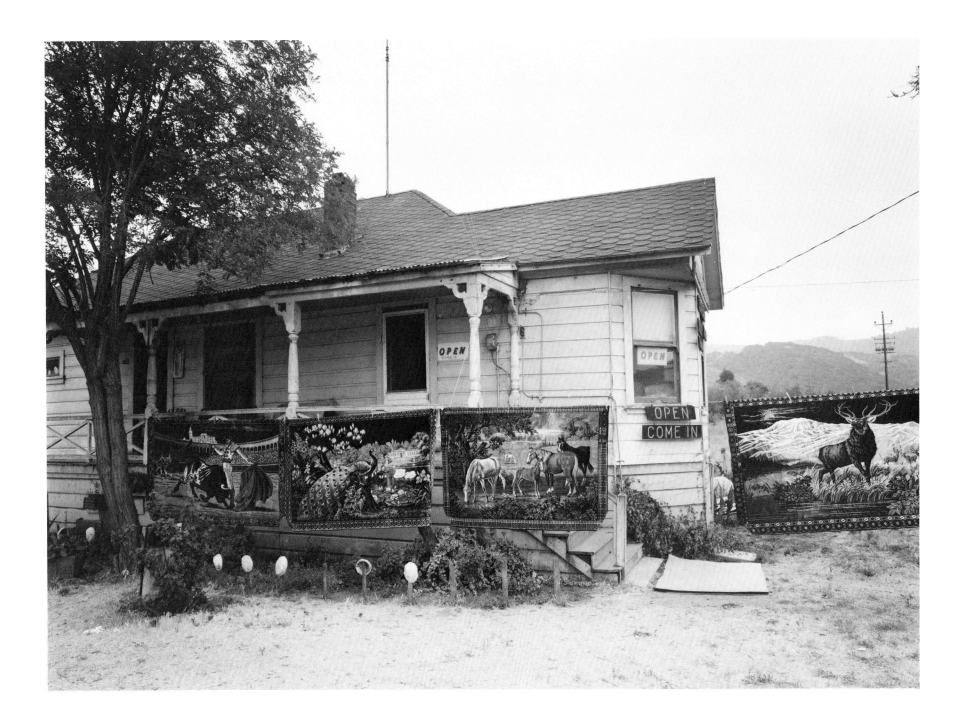

Wintersville, Ohio, 1971

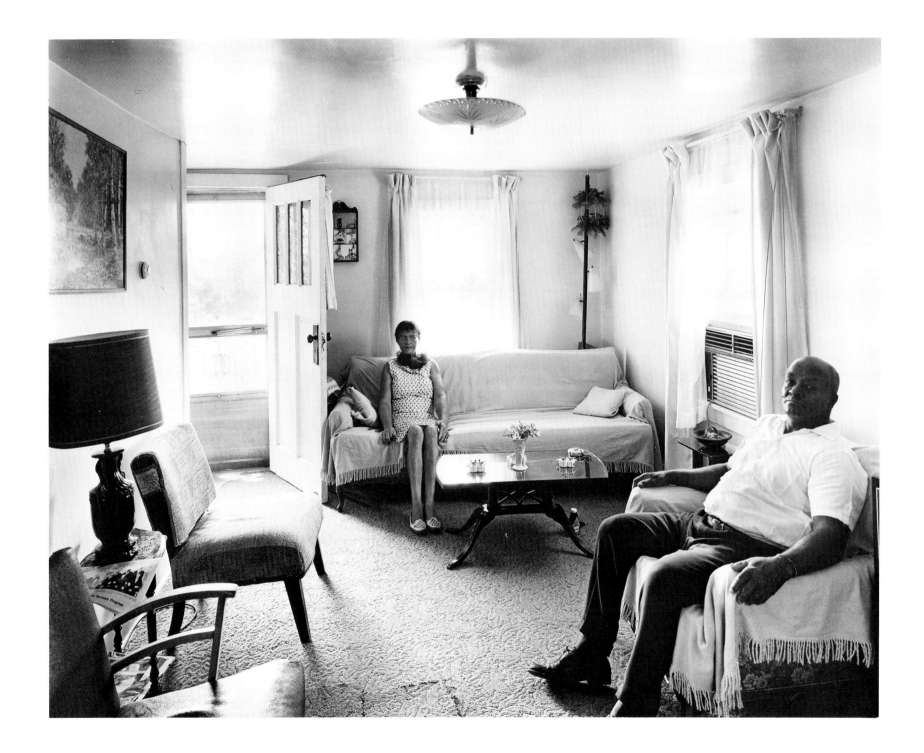

Cincinnati, Ohio, 1971

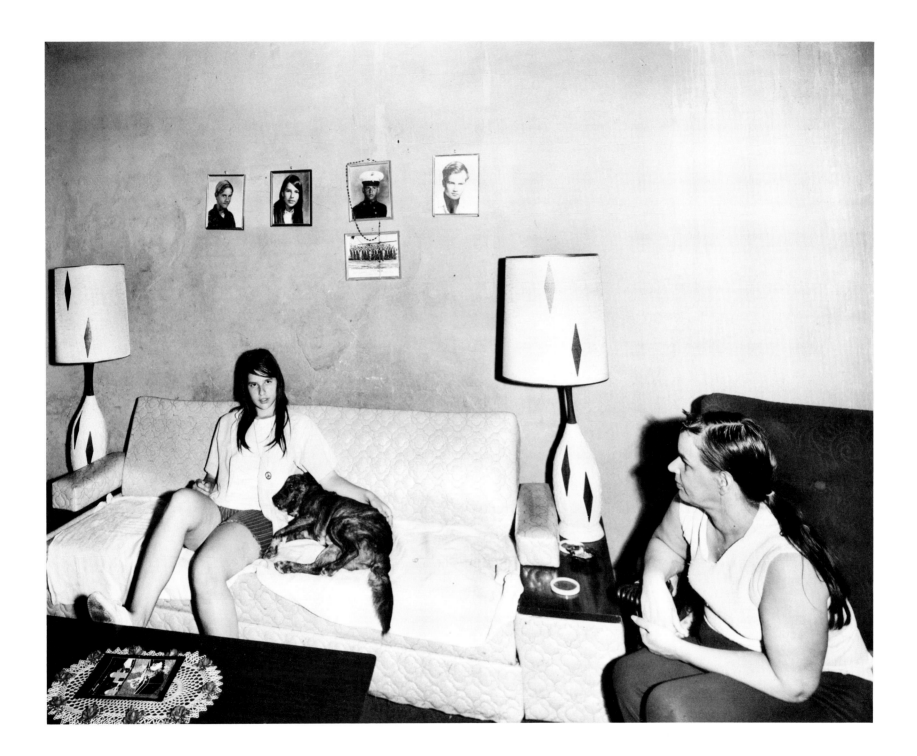

Monongahela, Pennsylvania, 1972

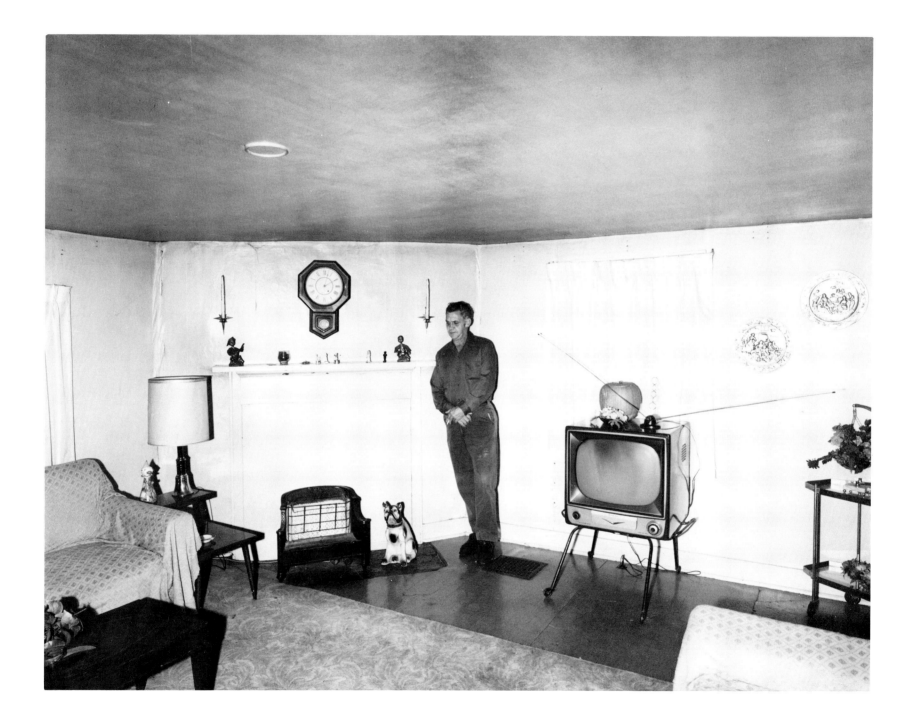

Oakland, California, 1968

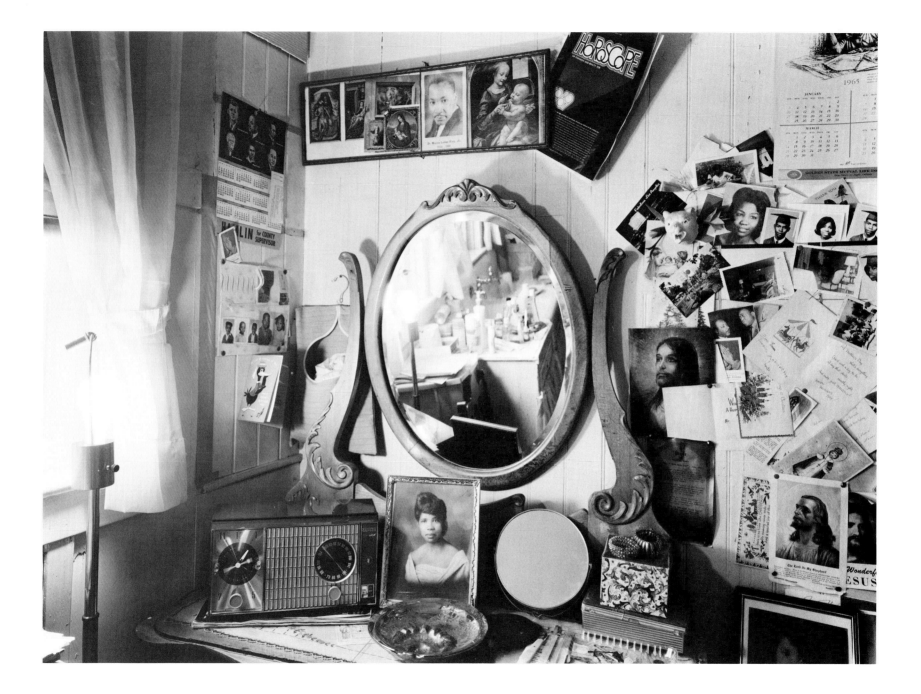

Nipomo, California, 1970

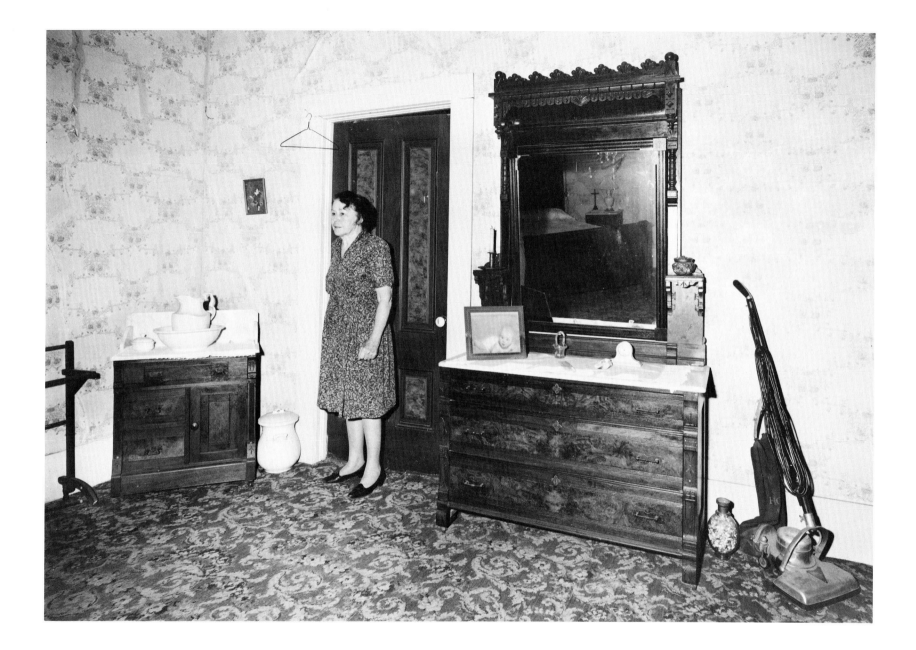

Johnstown, Pennsylvania, 1972

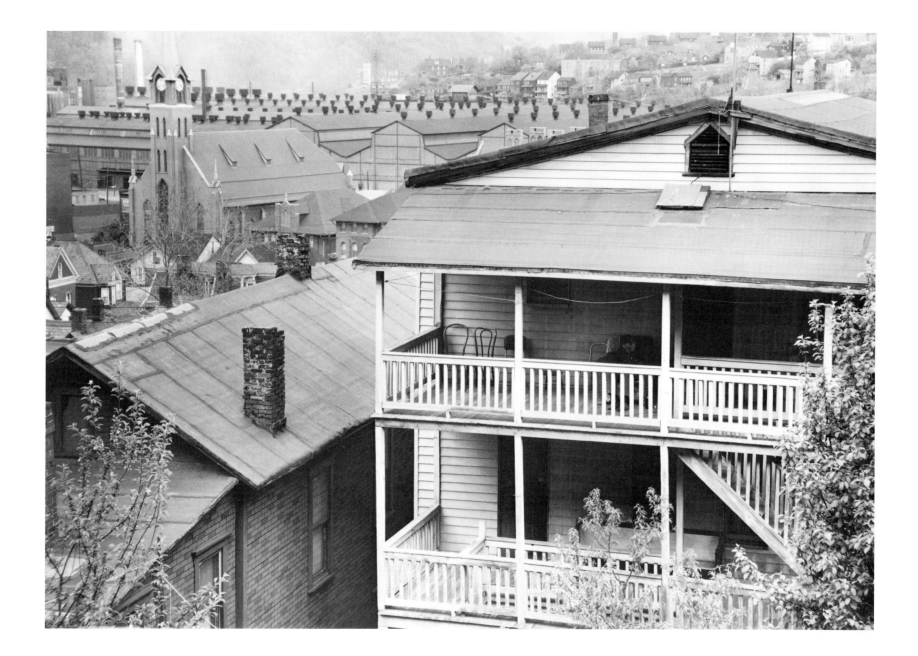

Mingo Junction, Ohio, 1971

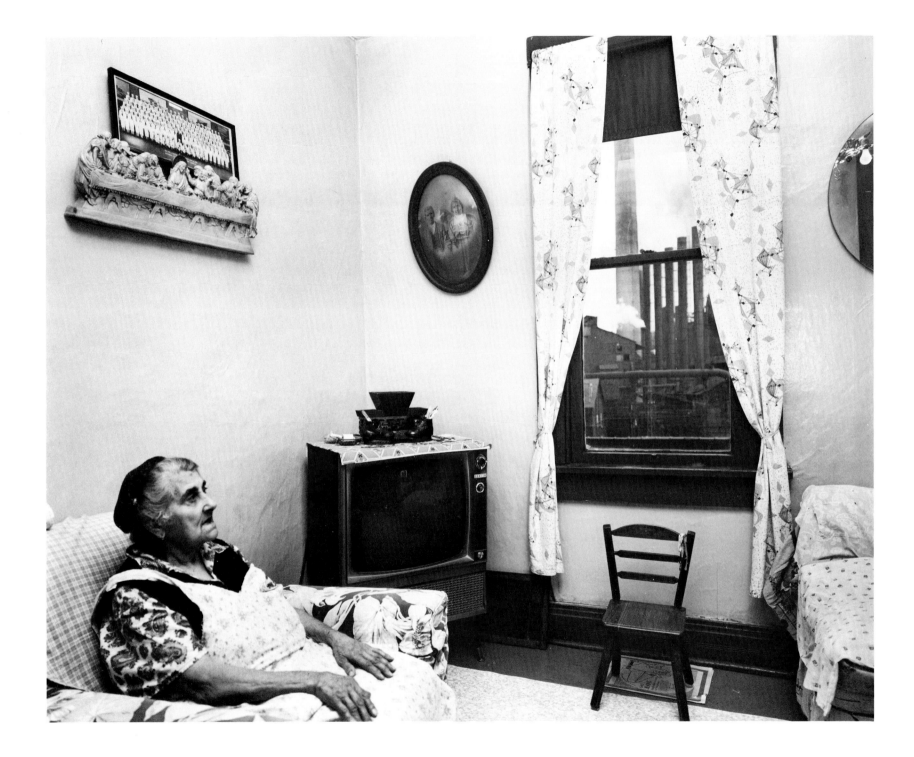

San Pablo, California, 1969

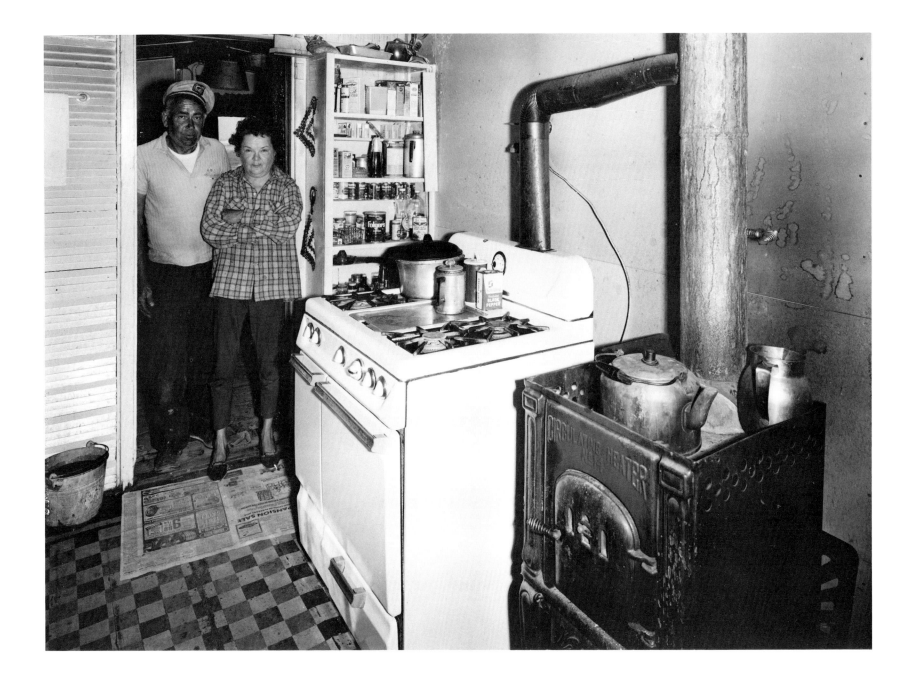

Albany, California, 1969

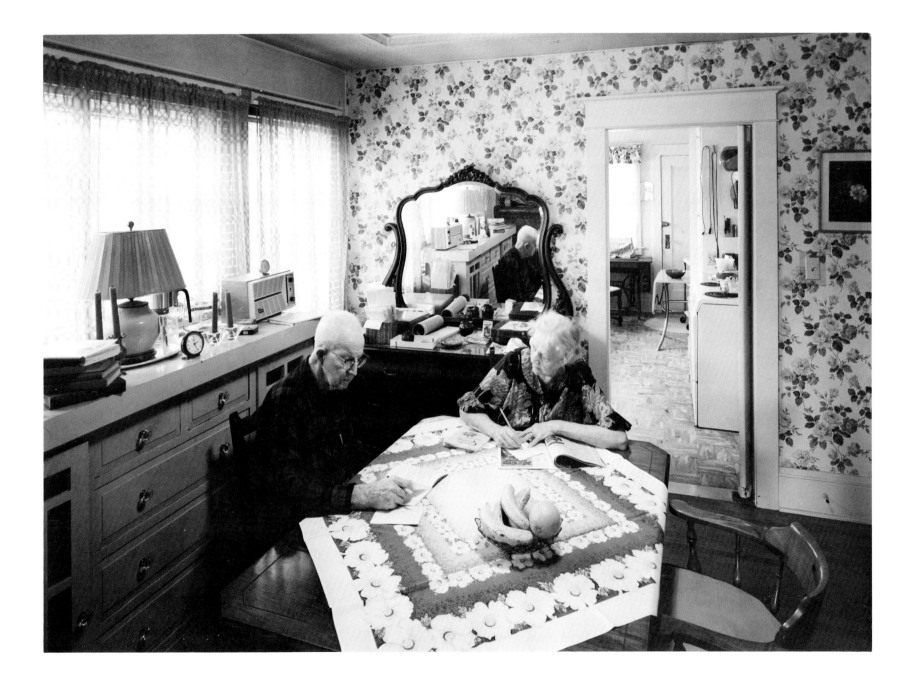

Selma, California, 1969

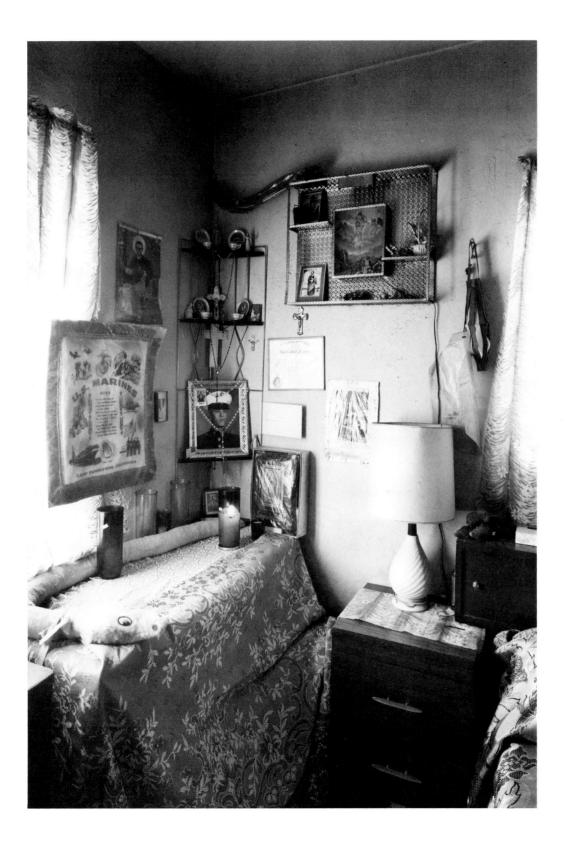

East Liverpool, Ohio, 1972

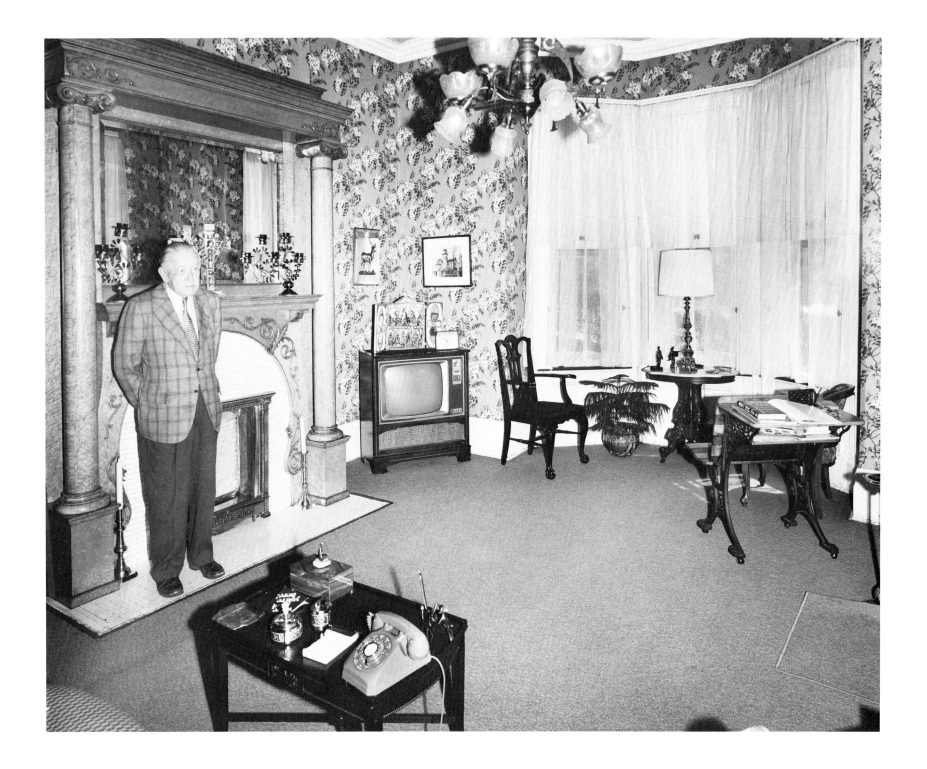

Parkersburg, West Virginia, 1971

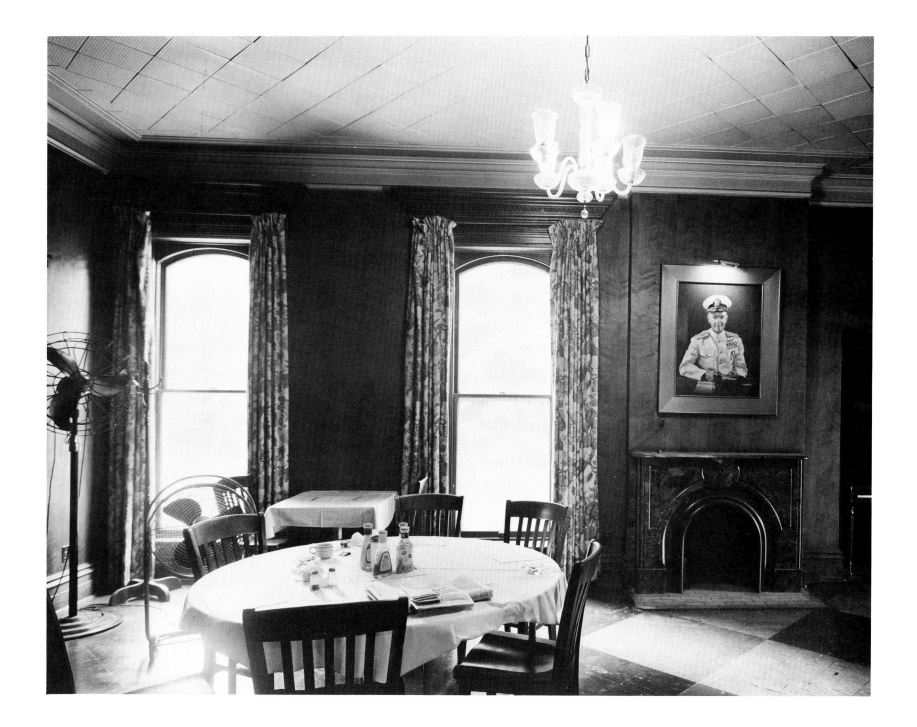

Jim Thorpe, Pennsylvania, 1970

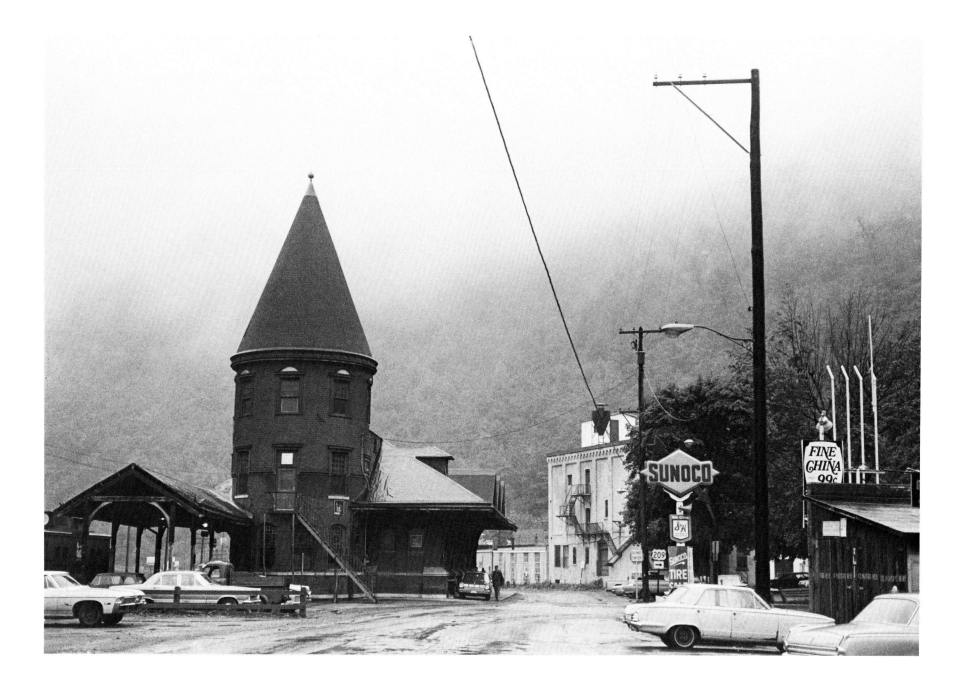

Donora, Pennsylvania, 1972

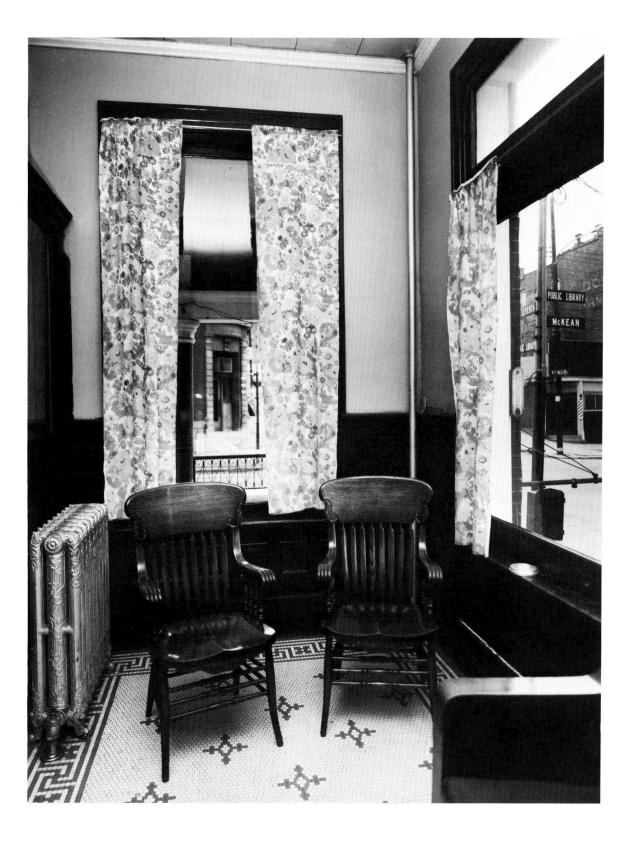

Toronto, Ohio, 1972

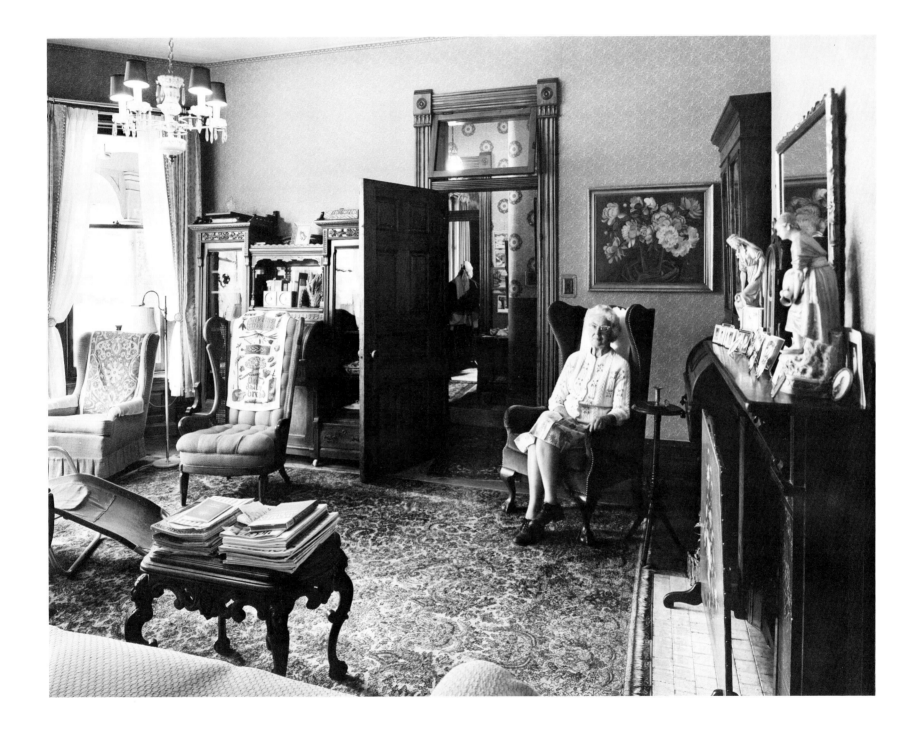

Coal Center, Pennsylvania, 1972

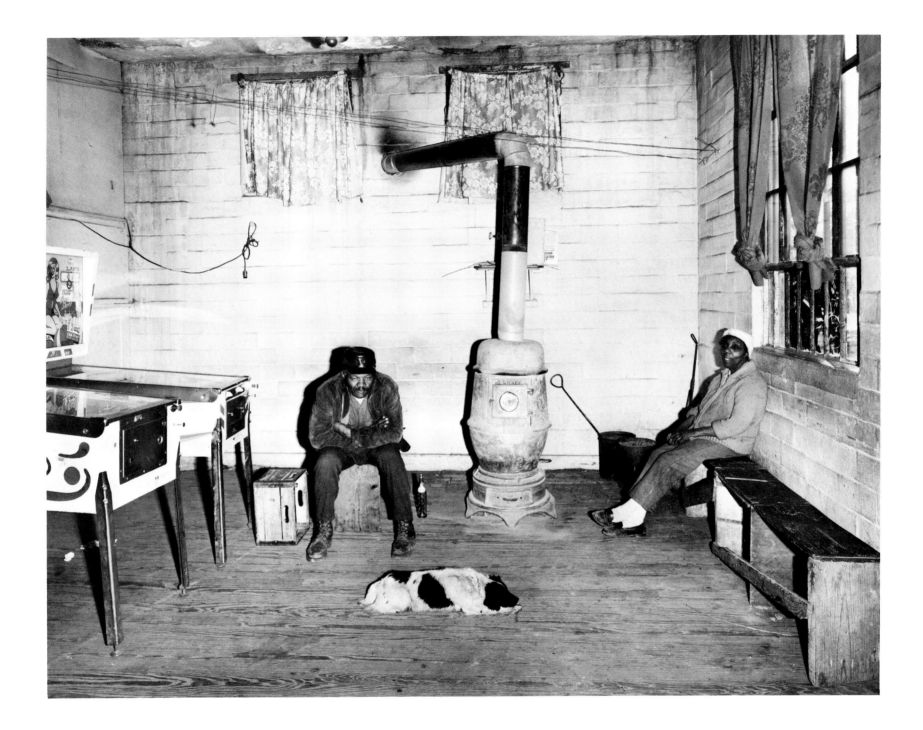

Cincinnati, Ohio, 1971

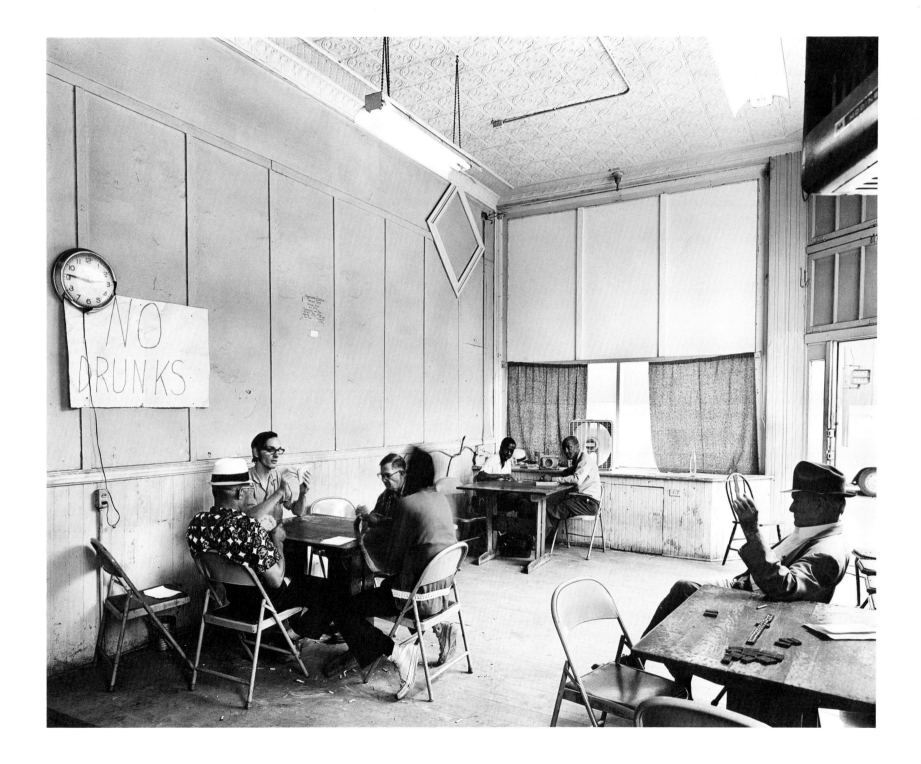

West Chester, Pennsylvania, 1972

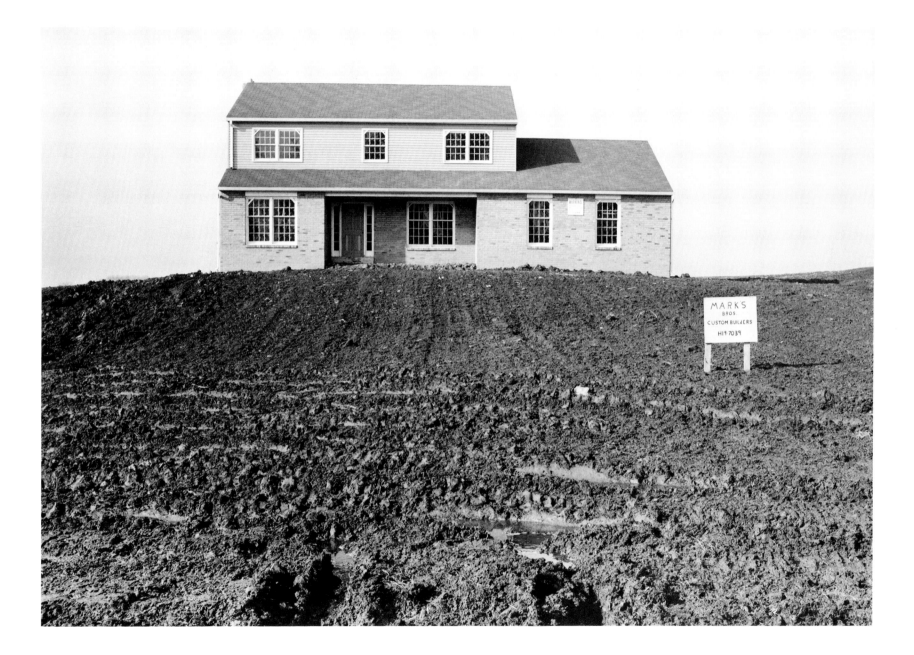

Oakland, California, 1968

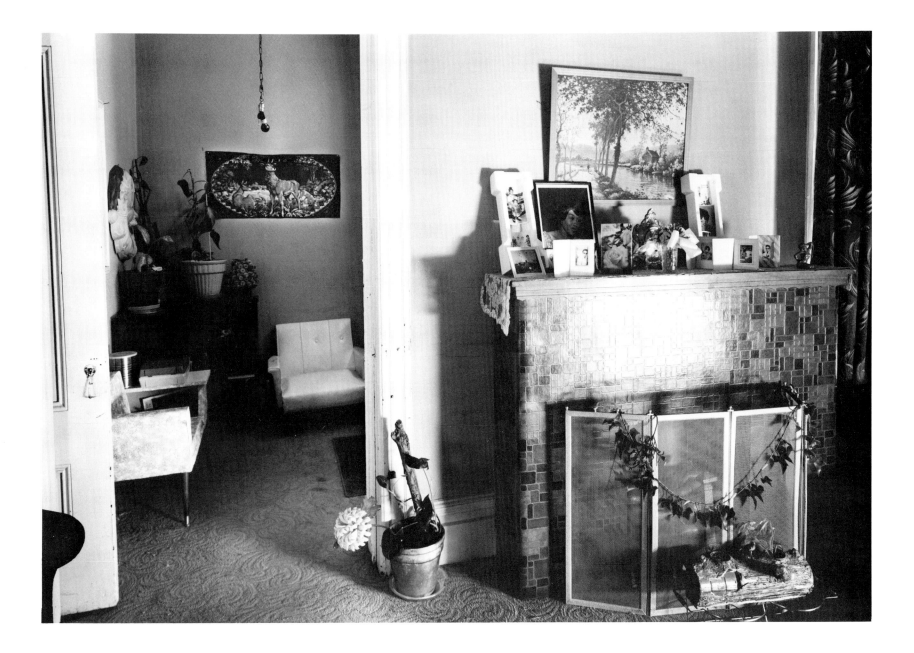

Richmond, California, 1969

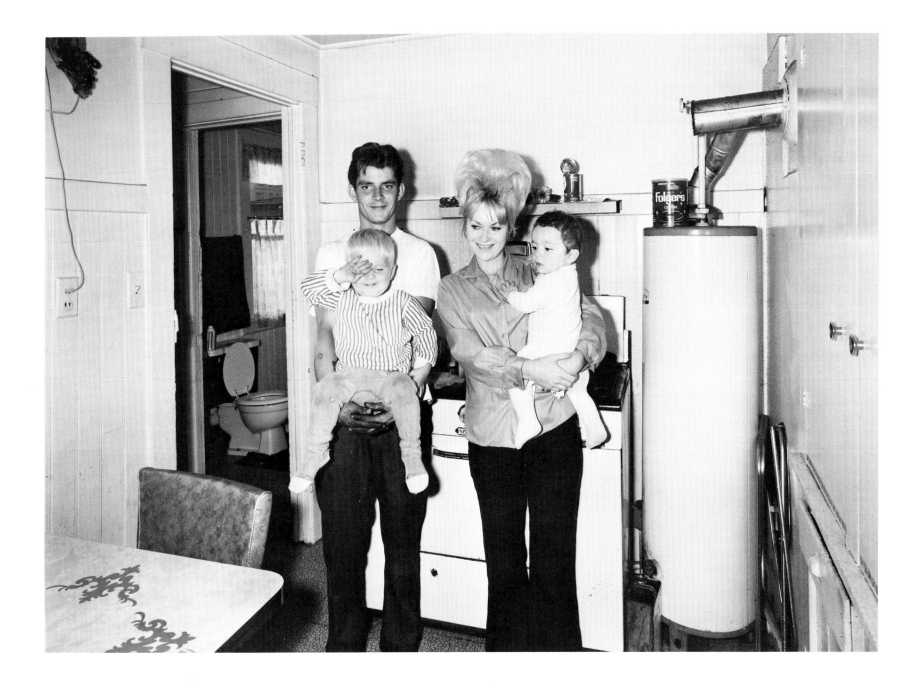

Steubenville, Ohio, 1971

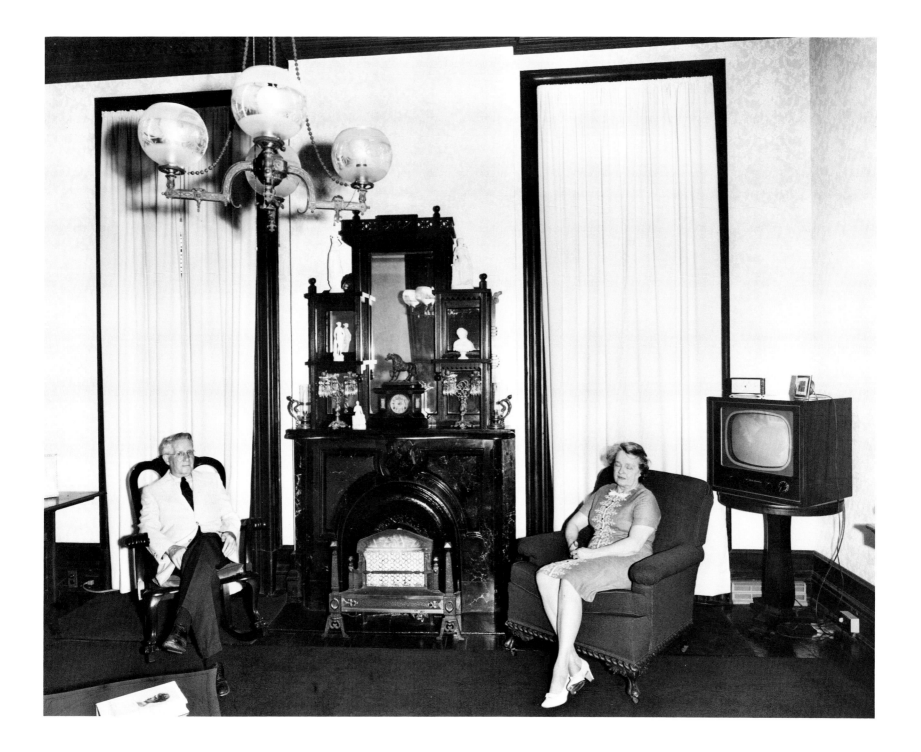

Oakland, California, 1969

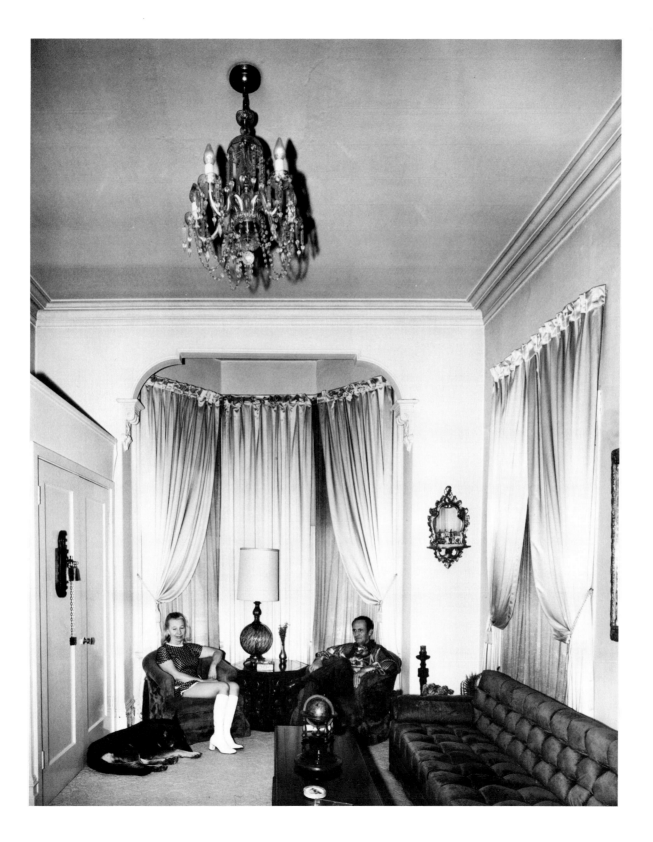

Oakland, California, 1969

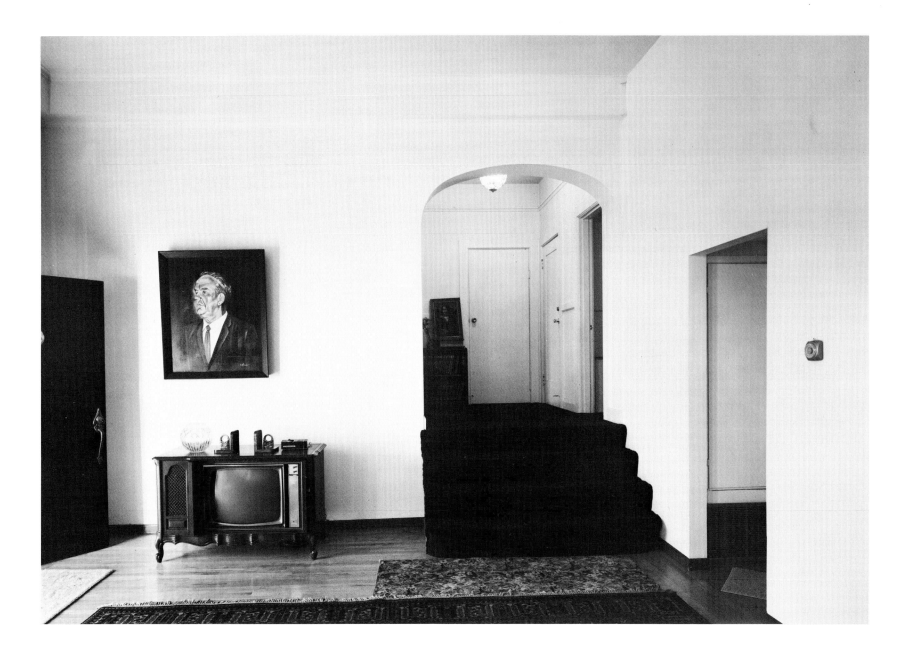

Weissport, Pennsylvania, 1972

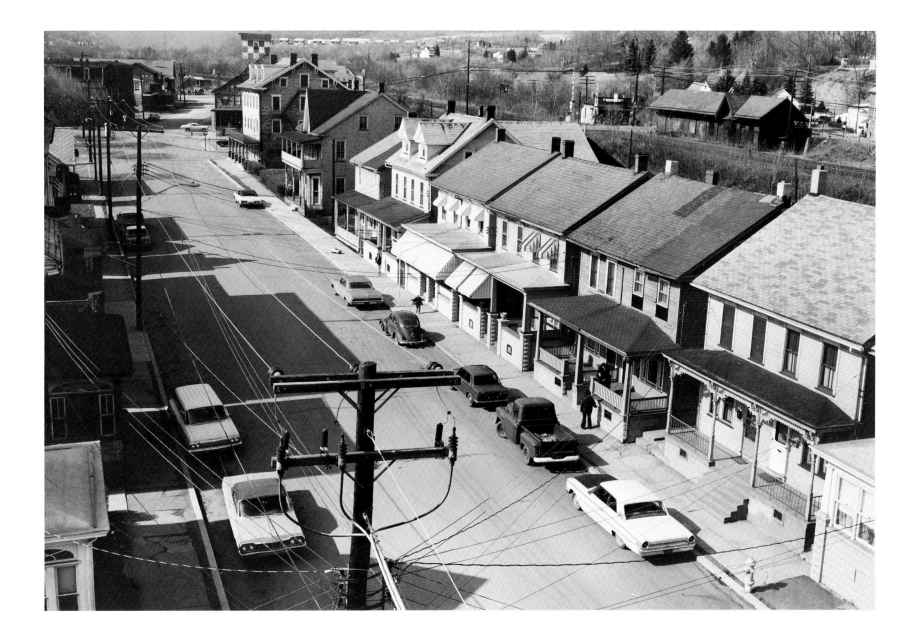

Oakland, California, 1969

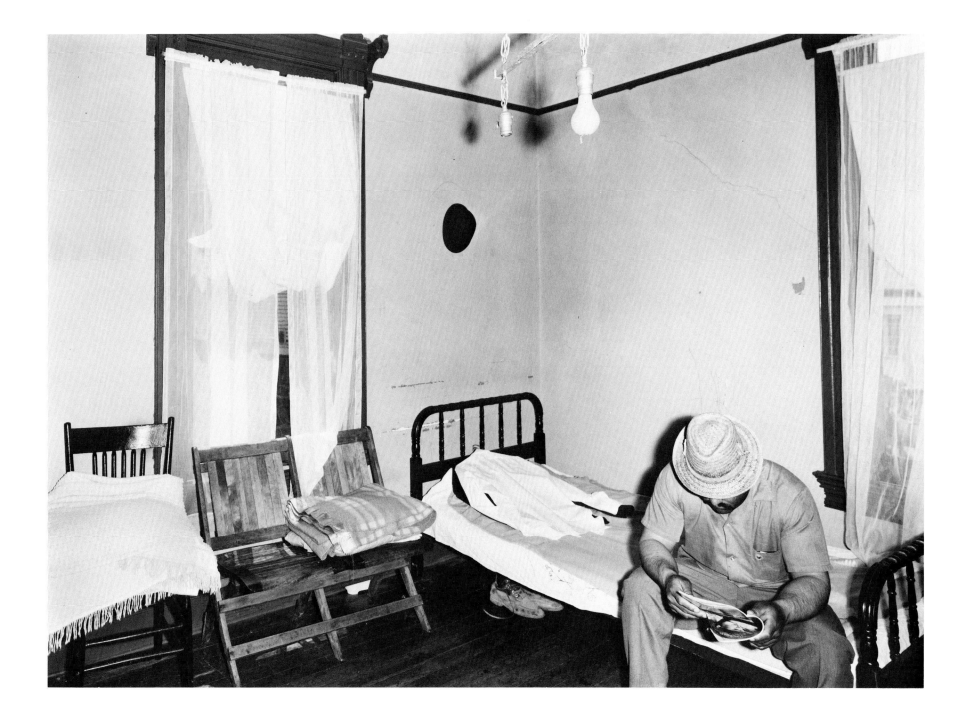

Cincinnati, Ohio, 1971

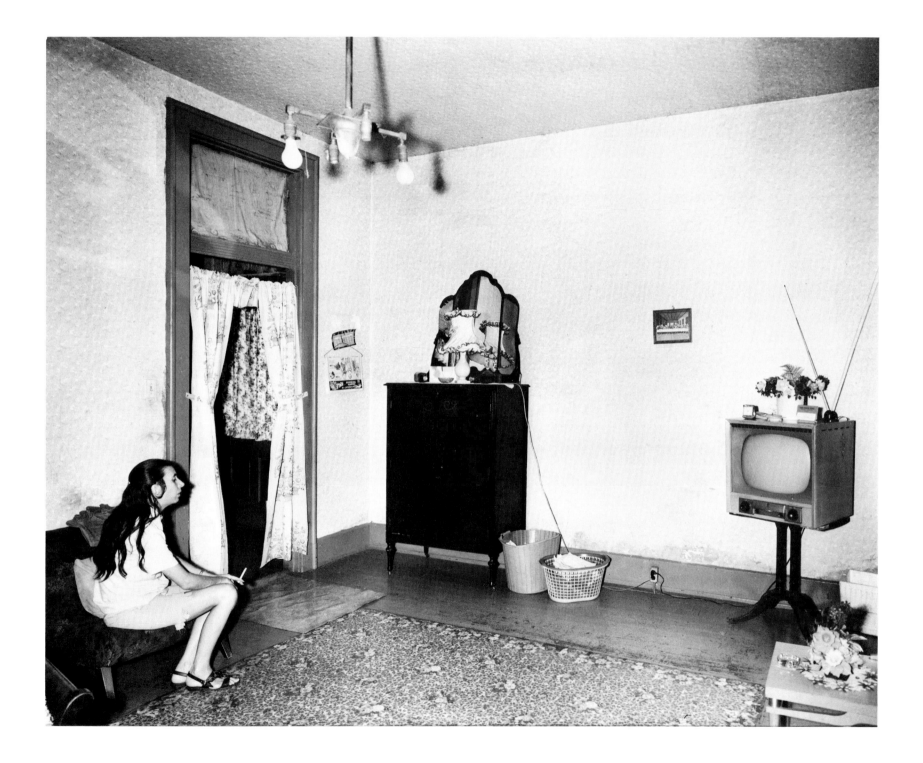

Richmond, California, 1969

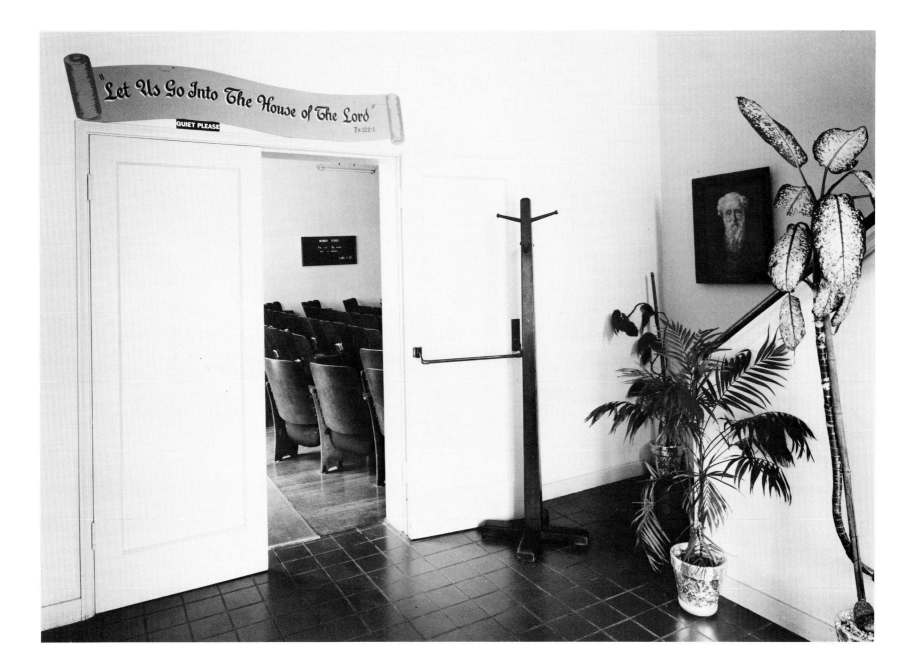

Berkeley, California, 1968

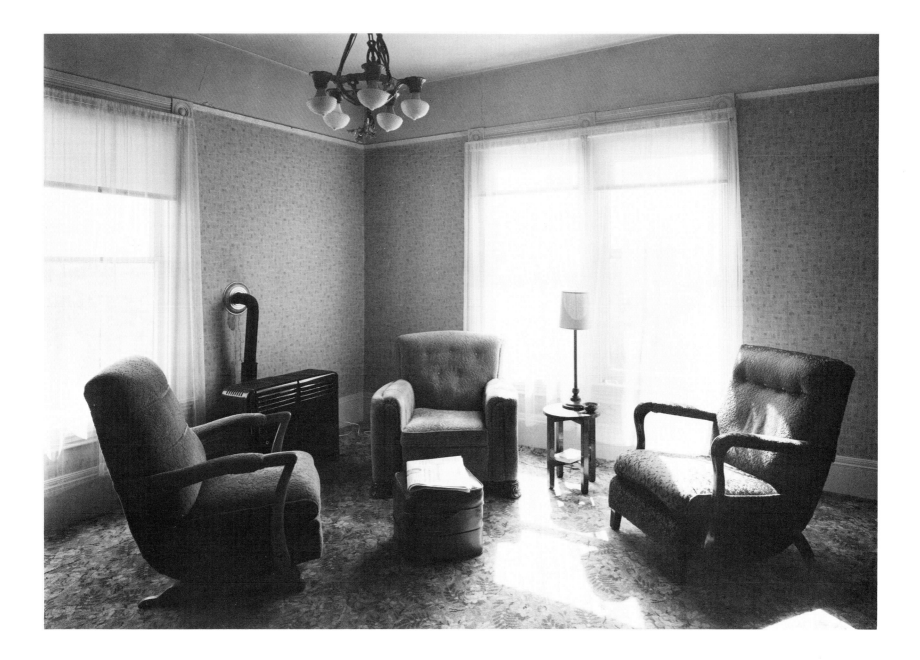

Mingo Junction, Ohio, 1971

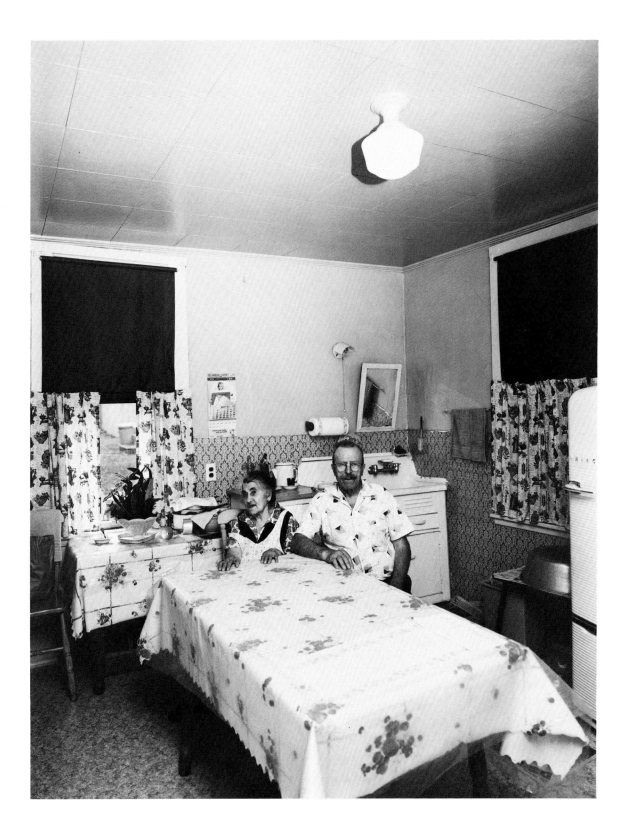

Oakland, California, 1969

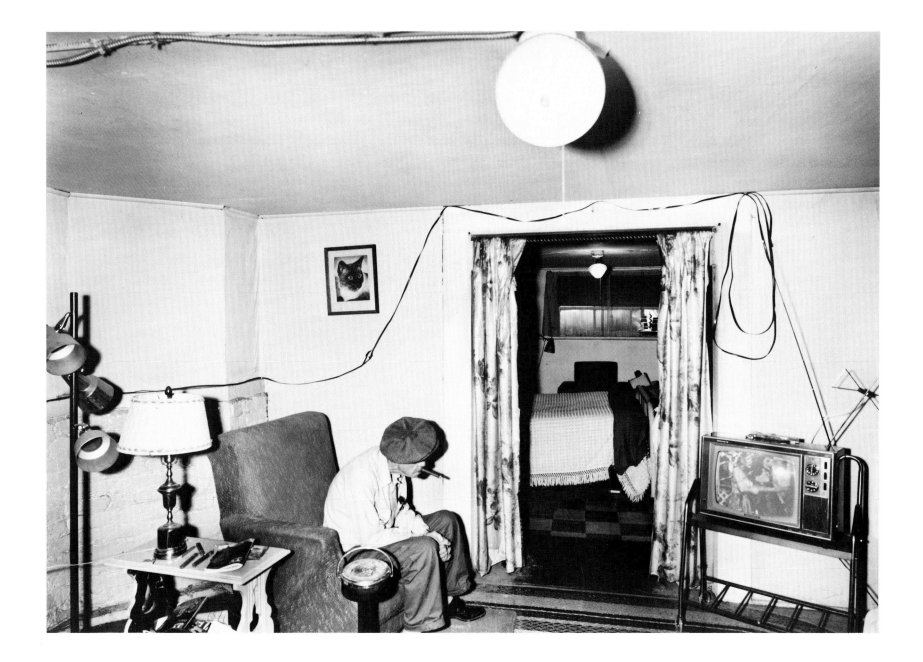

Steubenville, Ohio, 1971

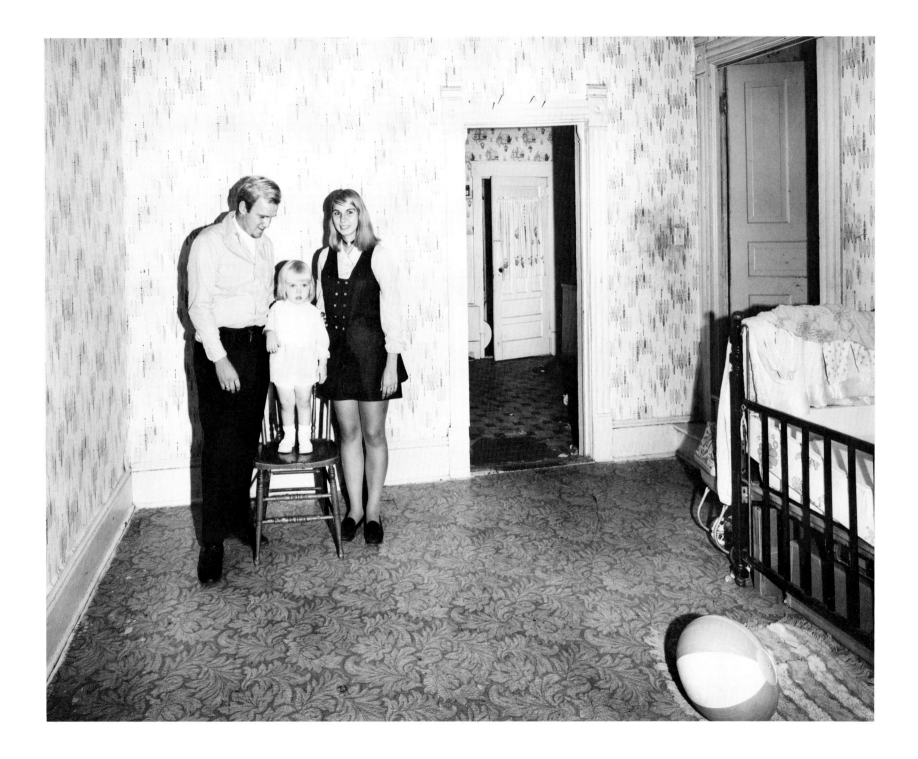

Wintersville, Ohio, 1971

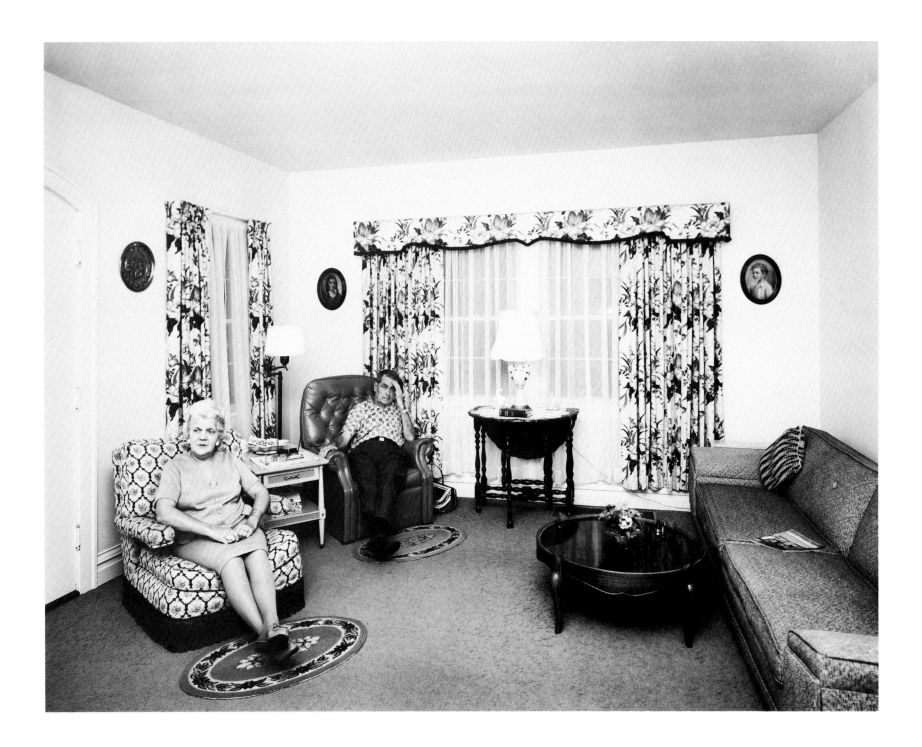

San Joaquin Valley, California, 1970

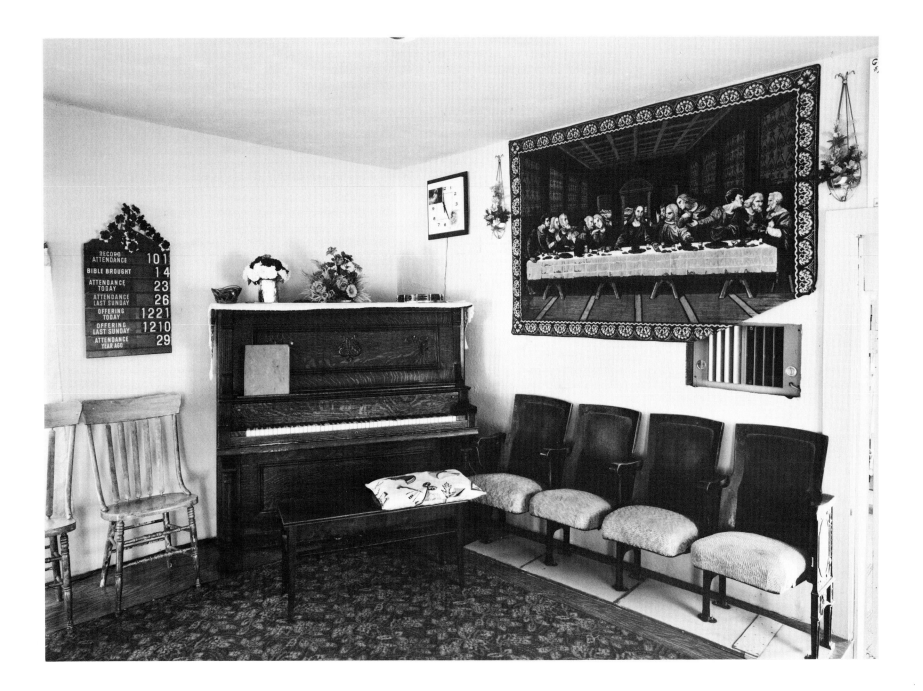

Oakland, California, 1969

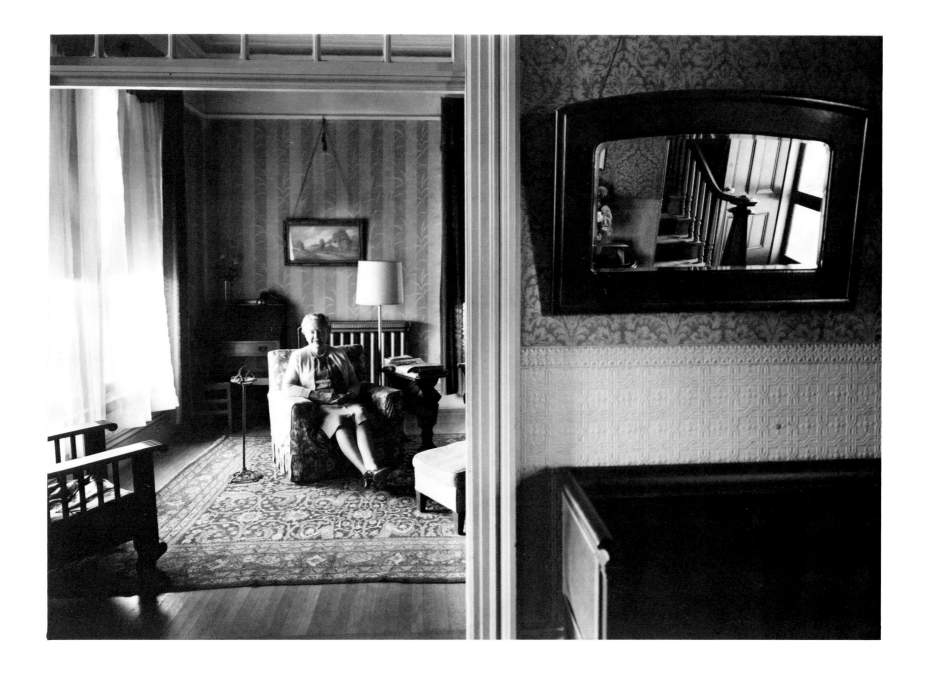

Oakland, California, 1969

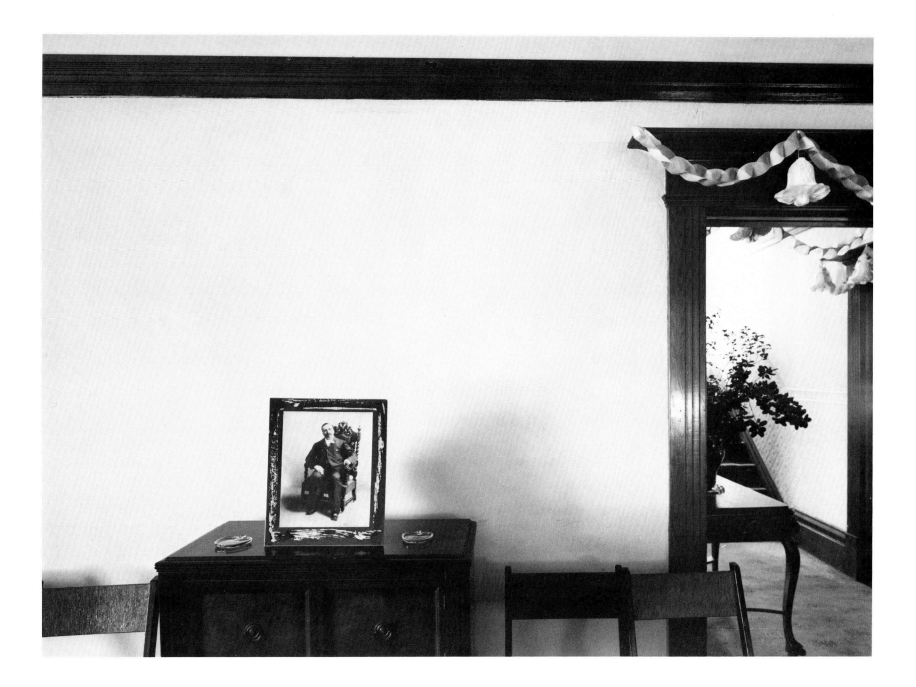

Richmond, California, 1970

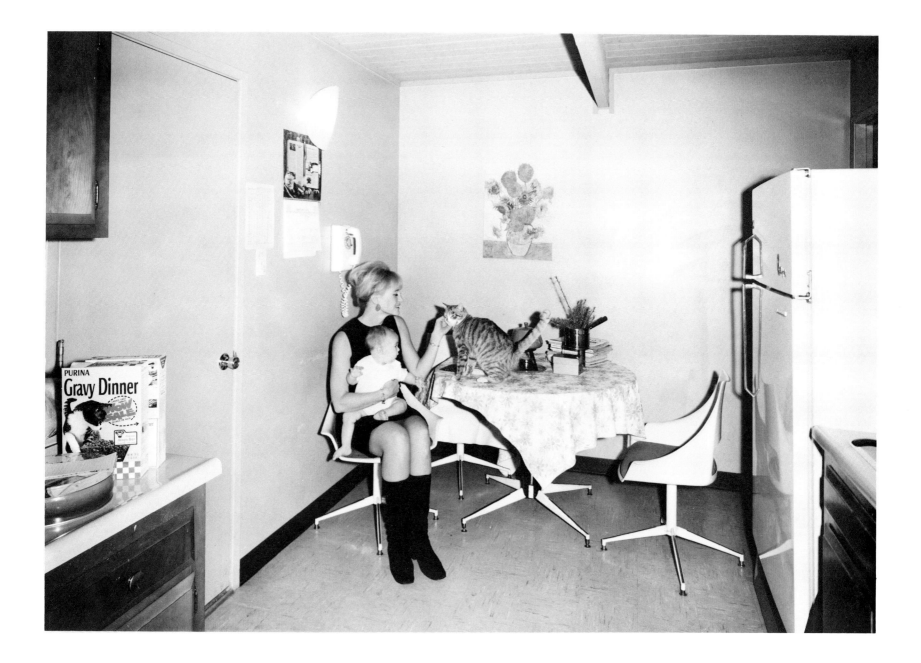

Sacramento Valley, California, 1969

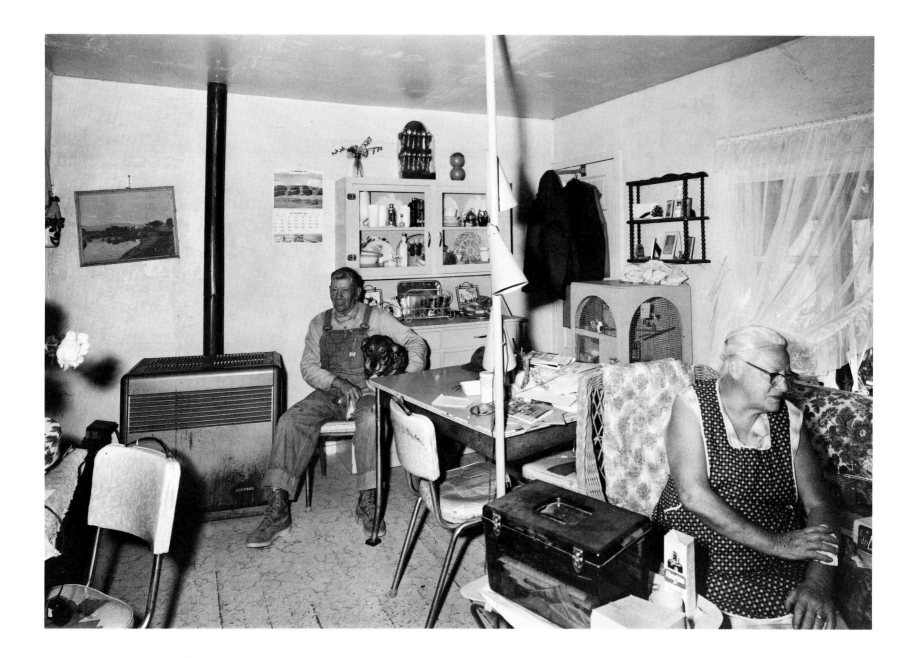

Cincinnati, Ohio, 1971

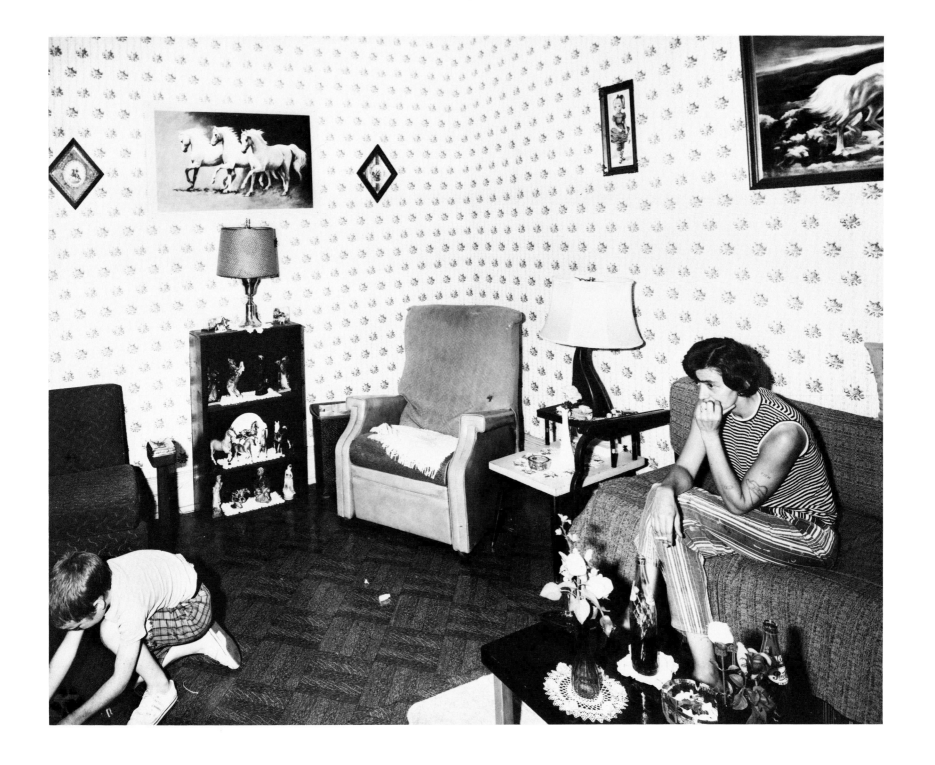

West Chester, Pennsylvania, 1971

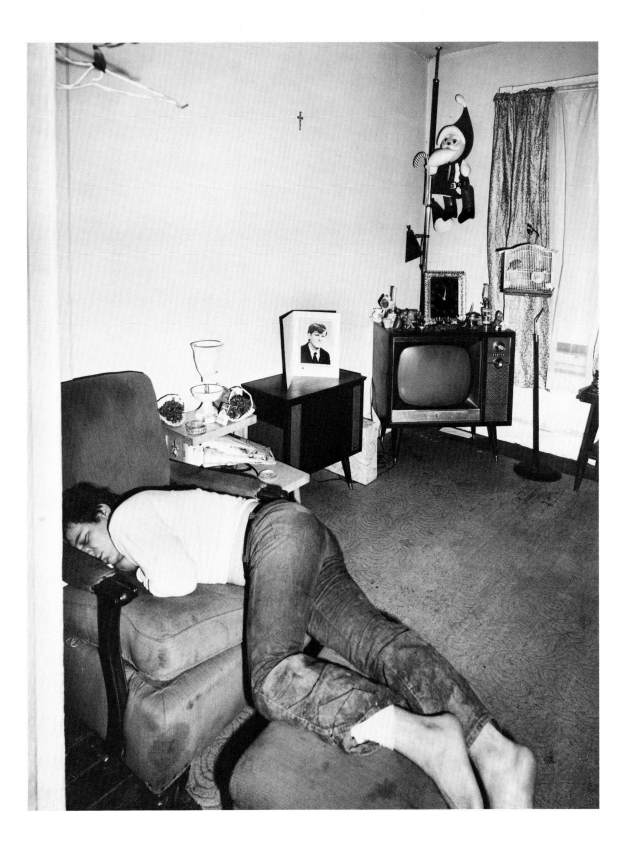

Richmond, California, 1968

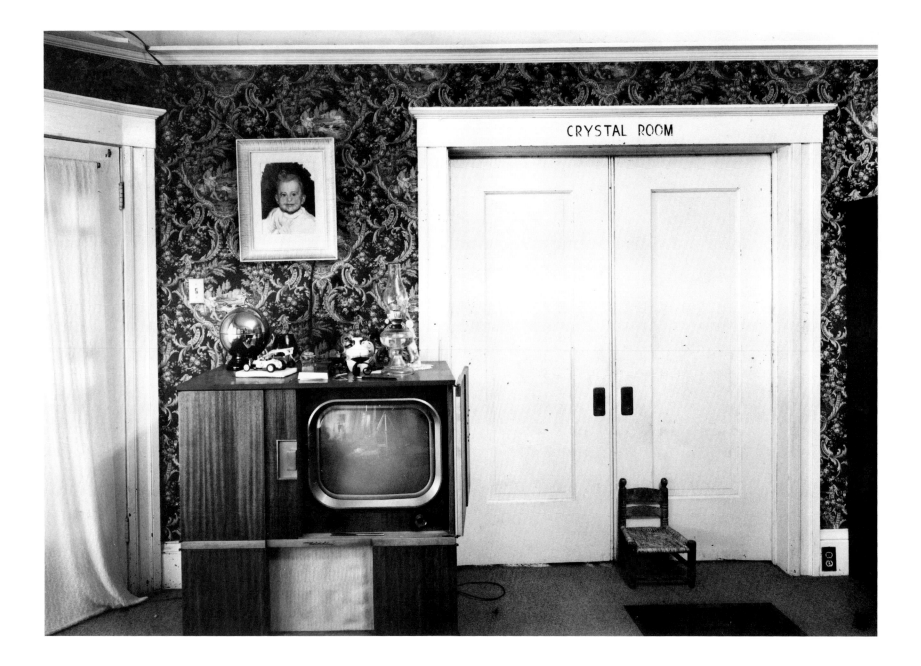

West Chester, Pennsylvania, 1972

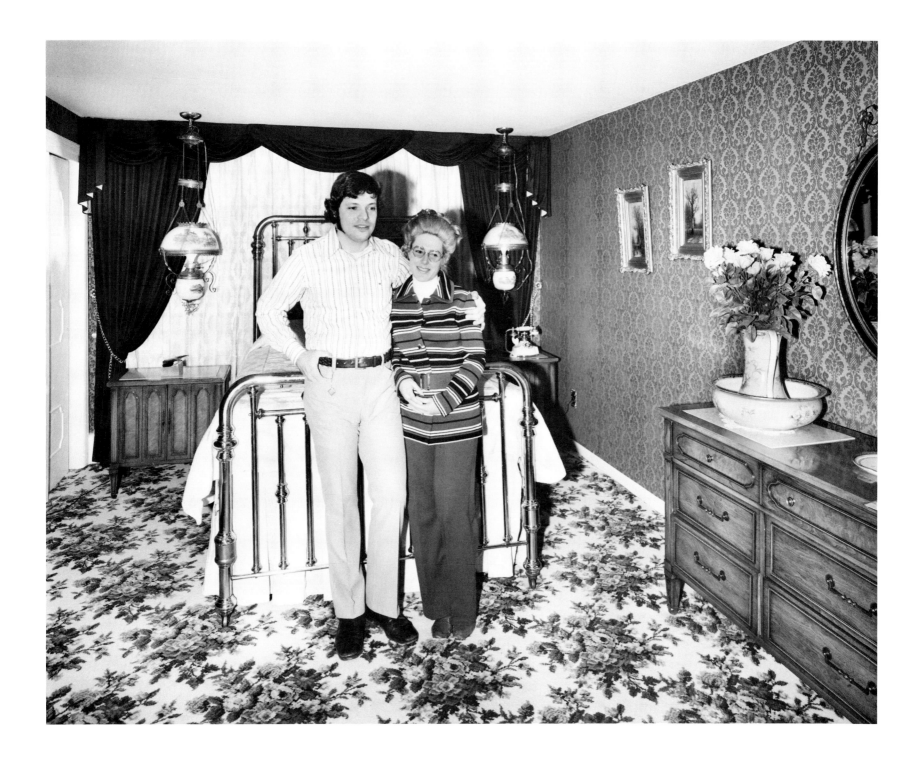

Oakland, California, 1970

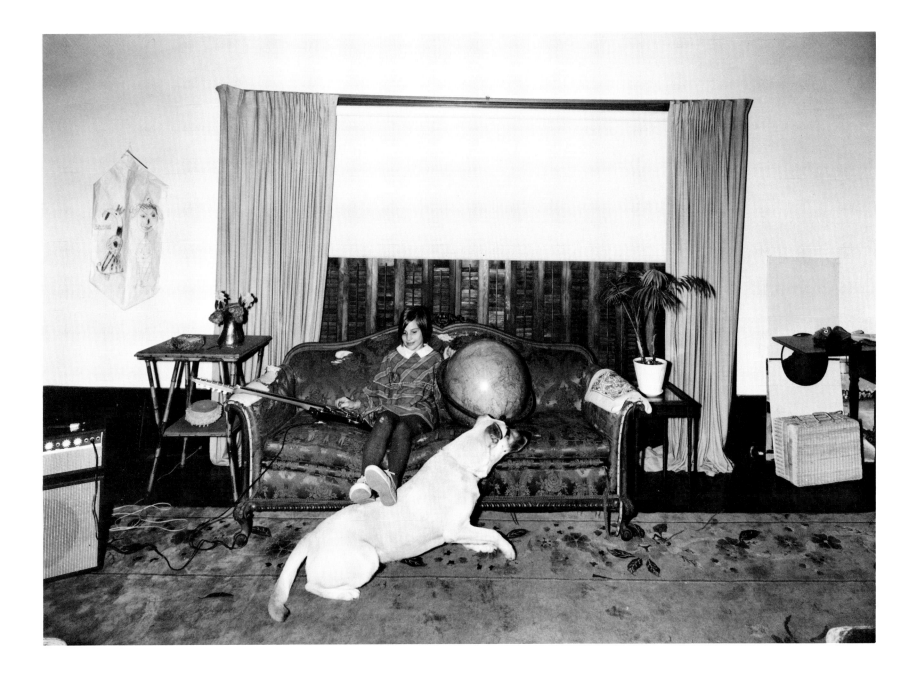

Weirton, West Virginia, 1971

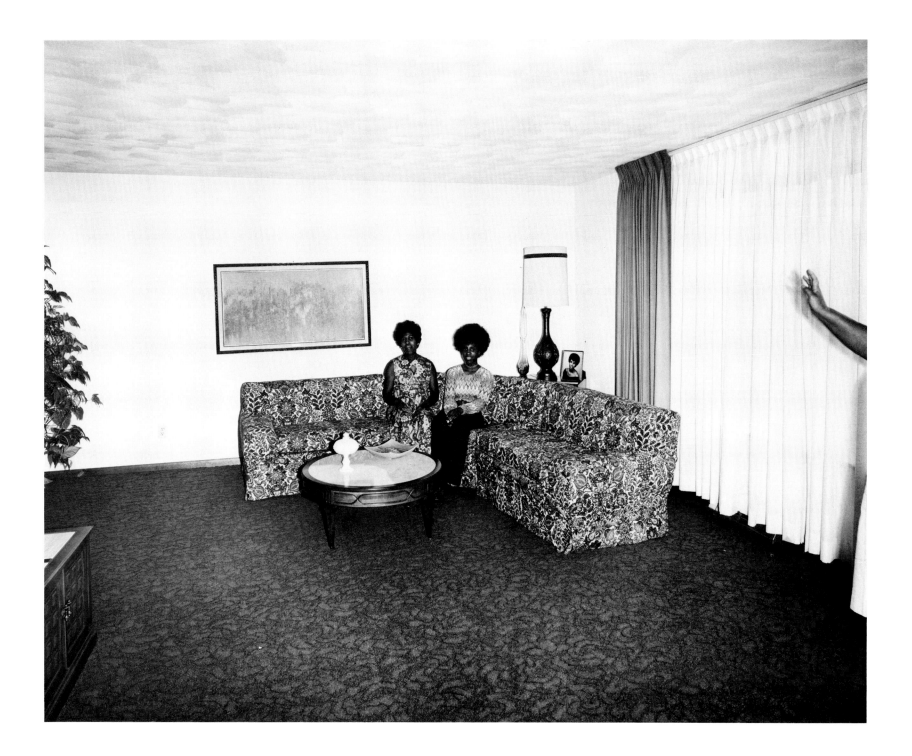

Cincinnati, Ohio, 1971

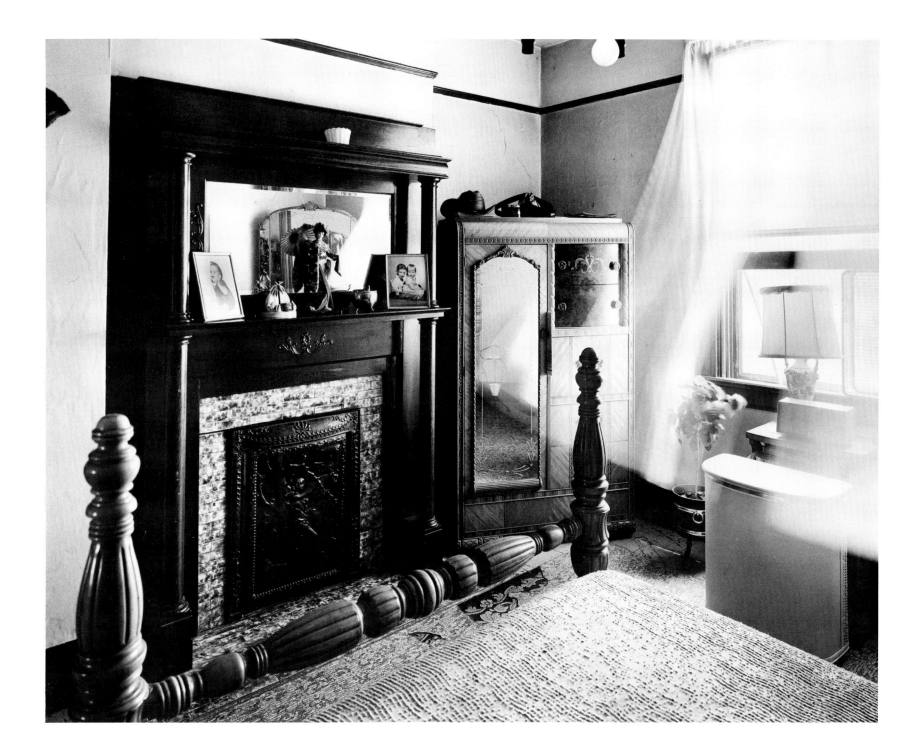

Richmond, California, 1968

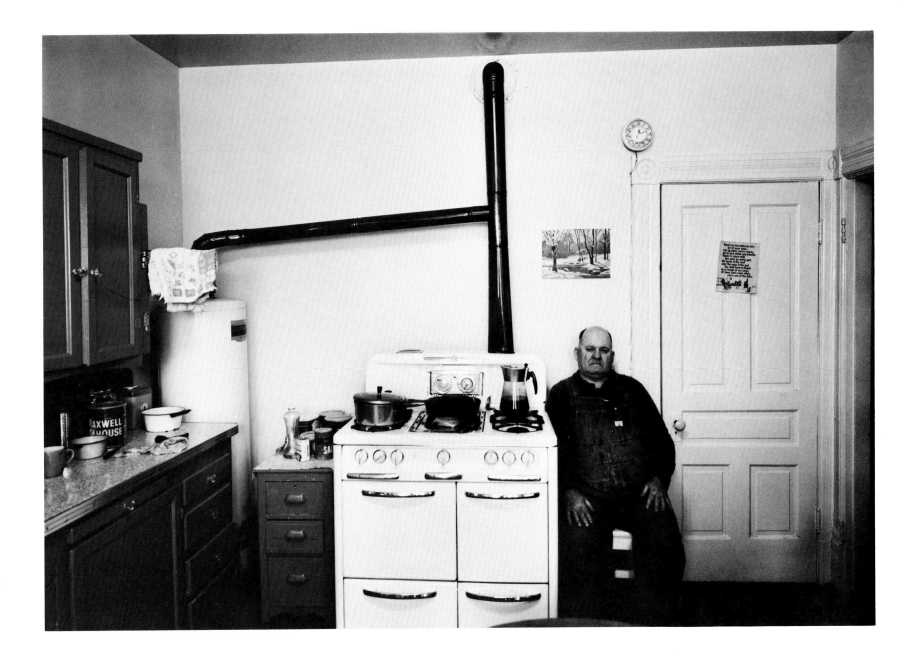

Lucedale, Mississippi, 1973

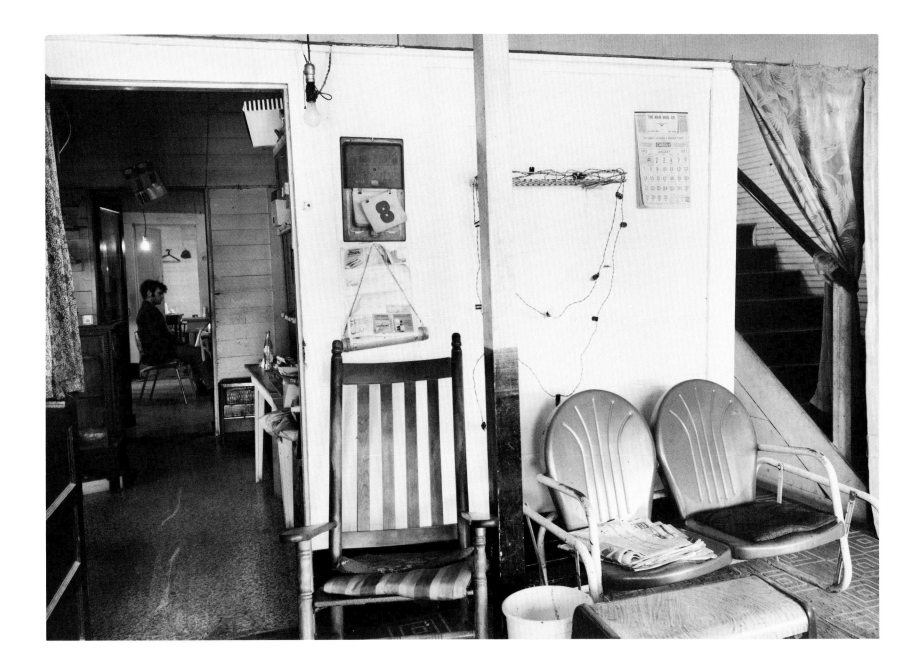

Jim Thorpe, Pennsylvania, 1971

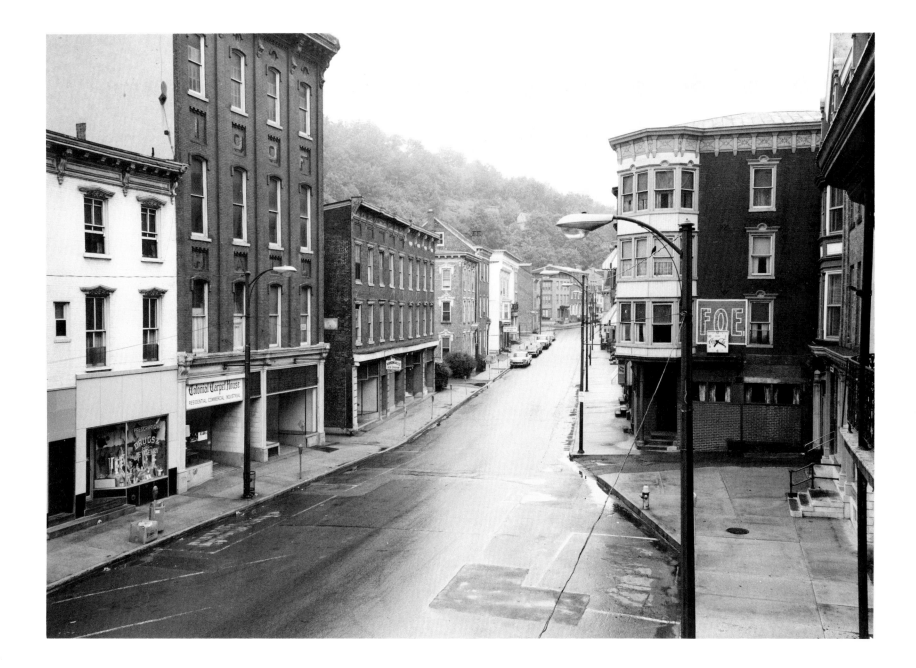

Toronto, Ohio, 1971

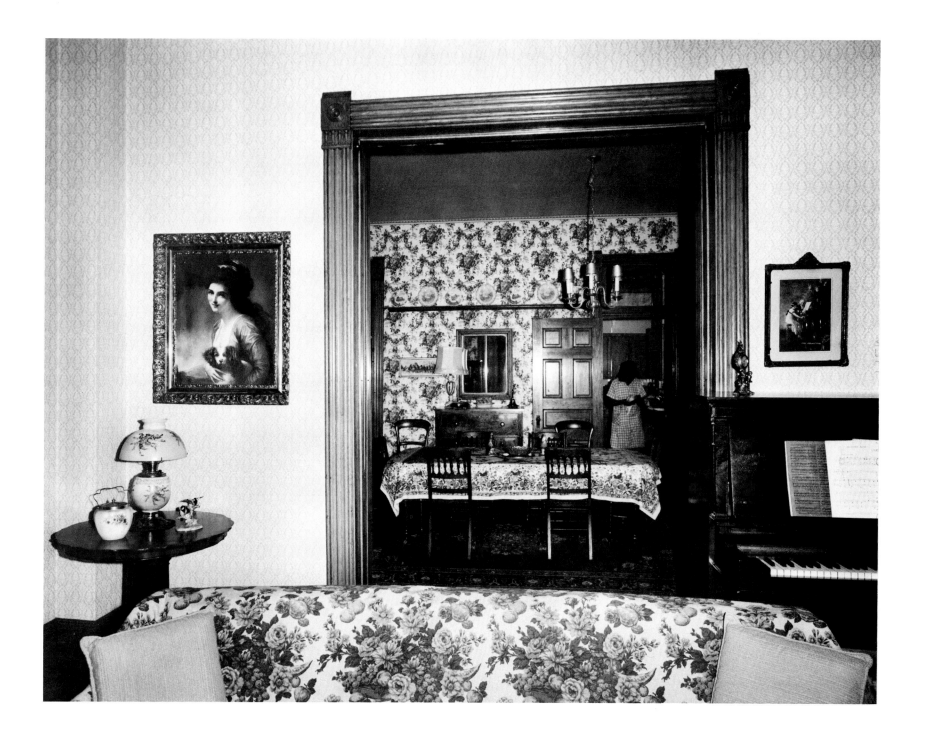

West Chester, Pennsylvania, 1971

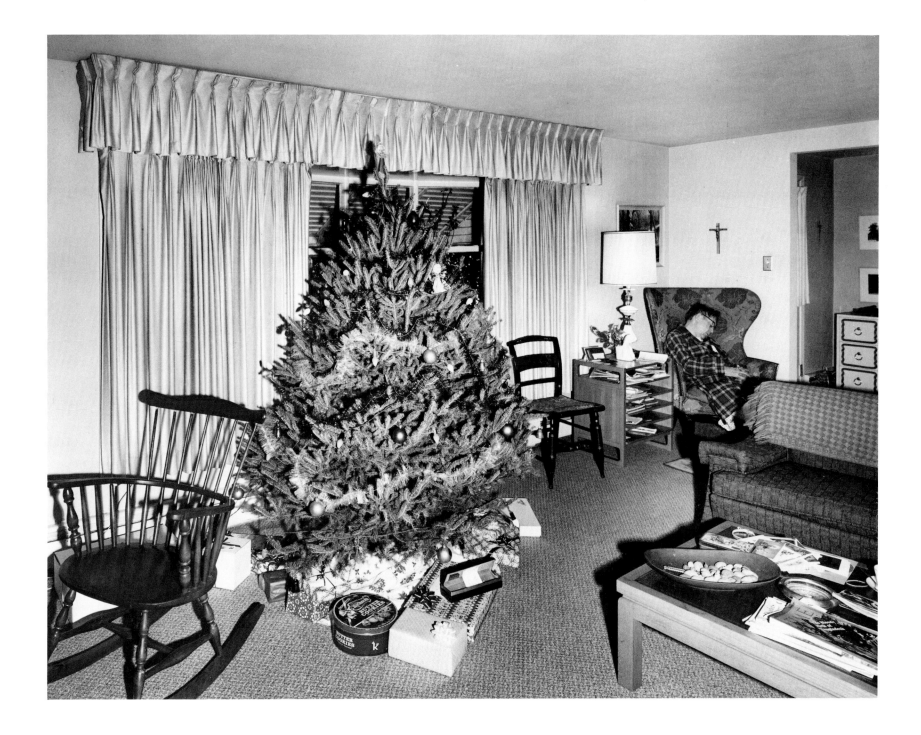

Saginaw, Michigan, 1968

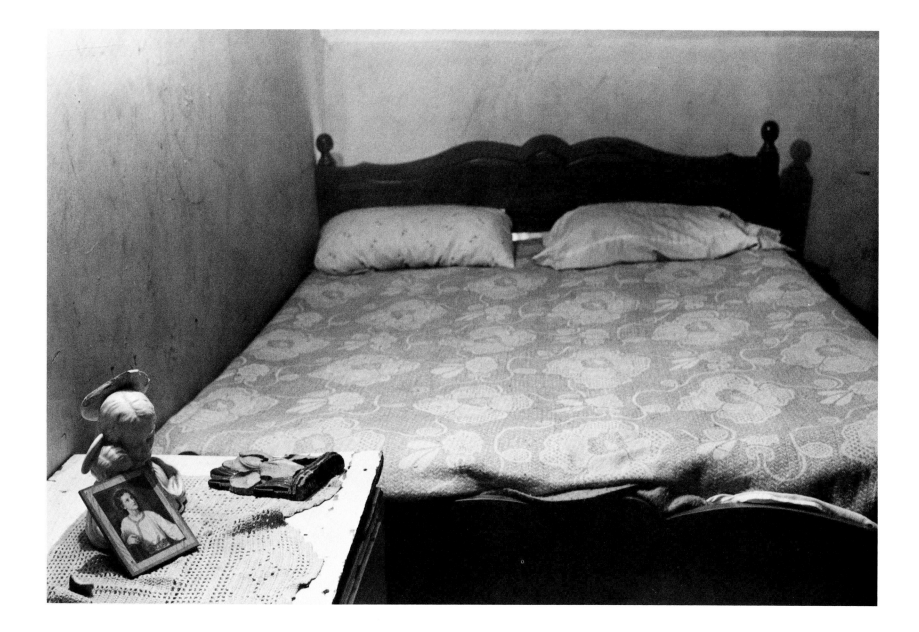